Contents

Matisse and Picasso: A Creative Dialogue

Henri Matisse and Pablo Picasso had known each other for almost half a century when Matisse died in 1954. In the early years it was a prickly relationship as they sized each other up and pursued diverging artistic goals. Their friendship was never as intimate and unconstrained as that between Matisse and Charles Camoin or Picasso and Georges Braque. There were periods when their paths did not cross and neither made the effort to renew direct contact. Symptomatically, no photograph of both of them together has so far come to light. Yet, whatever its limitations at the strictly personal level, at the artistic level the relationship was of sustained – and one is tempted to say – limitless importance to both men; beneath all the striking superficial differences there were profound affinities of motivation and attitude.

Even when they were not seeing one another, each artist was certainly watching the other's work and latest moves with beady-eyed vigilance. Mutual acquaintances understood this well and would play upon the feelings of rivalry and curiosity, and the craving for the other's good opinion, which lurked only just beneath the surface. Thus, if someone wanted to secure Matisse's cooperation in some venture, it was always helpful to be able to say that Picasso had agreed; and vice versa. And one could ingratiate oneself by telling the one that the other had been speaking warmly of him; on the other hand, it was a serious mistake to try to ingratiate oneself by criticising the other's work. In 1948,

when Matisse was at work on the designs for the Dominican Chapel of the Rosary at Vence, Father M.A. Couturier recorded the following conversation in his diary for 9 October:

> I tell him Picasso feels warmly toward him, that he was very moved to see his photograph tacked to the revolving bookshelves by his [Matisse's] bed. 'Yes, he's the only one who is entitled to speak ill of me.' One day he [Picasso] hears someone behind him say, 'I've just seen a rather ugly Matisse'. He turns round suddenly: 'You're wrong. Matisse never made an ugly painting.'[2]

At any given moment neither artist was necessarily exclusively interested in the other's latest work; it quite often happens that the most compelling and revealing parallels are between works that are years, sometimes many years, apart in date. Because both Matisse and Picasso were such prominent figures on the international art stage, the opportunities for this kind of observation and retrospection were legion: they might not be visiting each other's studios, but they could literally always see examples of each other's work in dealers' galleries in Paris, in the homes of collectors and in reproduction in the ever-increasing flood of books and journals. The fact that after the First World War art critics repeatedly, not to say compulsively, compared their work can only have whetted their curiosity. And though most critics presented them

Interpreting Matisse Picasso

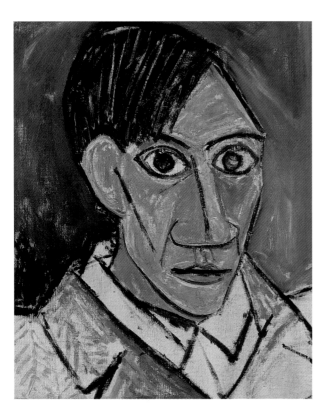 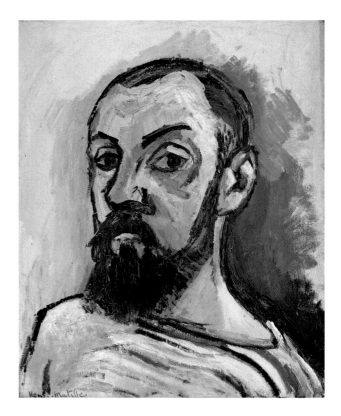

One day, meeting Max Jacob on one of the boulevards, I said
to him, 'If I were not doing what I am doing, I would like to
paint like Picasso'. 'Good heavens', said Max, 'how odd!
Do you know, Picasso said the same thing to me about you?'

Matisse in conversation with Pierre Courthion, 1941[1]

Interpreting Matisse Picasso

ELIZABETH COWLING

TATE PUBLISHING

The *Matisse Picasso* exhibition at Tate Modern is sponsored by

ᴇᴜ ERNST & YOUNG

Published to accompany the *Matisse Picasso* exhibition
at Tate Modern, London
11 May – 18 August 2002

Le Grand Palais, Paris
25 September 2002 – 6 January 2003

The Museum of Modern Art, New York
13 February – 19 May 2003

First published 2002 by order of the Tate Trustees
by Tate Publishing, a division of Tate Enterprises Ltd,
Millbank, London SW1P 4RG
www.tate.org.uk

British Library cataloguing in publication data
A catalogue record for this book is available from
the British Library

ISBN 1 85437 393 5

Distributed in North and South America by
Harry N. Abrams, Inc., New York, under the following ISBN:
ISBN 0 8109 6258 6

Library of Congress cataloging in publication data
Library of Congress Control Number: 2002104369

Designed by Philip Lewis
Printed in Italy by Conti Tipocolor, Florence

Front cover: Matisse, *Large Reclining Nude (The Pink Nude)* 1935
(fig.55)
Back cover: Picasso, *The Dream* 1932 (fig.54)
Frontispiece: Matisse, *Self-Portrait* 1906, oil on canvas
55 × 46 cm. Statens Museum for Kunst, Copenhagen. Johannes
Rump Collection
Picasso, *Self-Portrait* 1907, oil on canvas 50 × 46 cm. National
Gallery, Prague

ACKNOWLEDGEMENTS

I am profoundly indebted to the five distinguished colleagues
with whom I have had the privilege to work for several years on the
Matisse Picasso exhibition, opening at Tate Modern in May 2002:
Anne Baldassari, John Elderfield, Isabelle Monod-Fontaine,
Kirk Varnedoe and especially John Golding, with whom I have
collaborated most closely. I am also indebted to the scholarship
of many writers on Matisse and Picasso, but wish particularly
to single out Yve-Alain Bois's groundbreaking study of their
relationship, published by Flammarion in 1998. I also warmly
thank John Golding and Ruth Rattenbury for sparing the time
to read the manuscript and for their very helpful comments
and suggestions. Finally, I should like to thank my editor
Judith Severne, who has been a model of efficiency and patience.

PICTURE CREDITS

Acquavella Galleries, New York 62; Albright-Knox Art Gallery,
Buffalo 56; Archives Matisse, Paris 1; Archives Picasso, Paris 2,
11; The Baltimore Museum of Art 3, 13, 55; Beyeler Foundation,
Riehen/Basel 18; Bridgeman Art Library 15; CNAC/MNAM
Dist.RMN 29; CNAC/MNAM Dist.RMN, Jacqueline Hyde 57;
CNAC/MNAM Dist.RMN, Adam Kzepka 47; CNAC/MNAM
Dist.RMN, Philippe Migeat 9, 22, 32, 60; Helly Nahmad Gallery,
London 64; Kunstsammlung Nordrhein-Westfalen, Düsseldorf,
Walter Klein 59; Courtesy of the Lender 21, 54, 63, 65; Matisse
Photo Archives, Paris 68; The Metropolitan Museum of Art, New
York 4; Musée de Grenoble 25; Musée Picasso, Paris, R.G.Ojéda
33; The Museum of Modern Art, New York 7, 10, 12, 24, 27, 35,
36, 37, 38, 39, 45, 48, 51, 53; National Gallery of Art, Washington
66; National Gallery, Prague *frontis.* (right); Orlando Photo-
graphie 67; The Phillips Collection, Washington DC 44; RMN
40; RMN, J.G. Berizzi 49; RMN, Bulloz 8; RMN, B. Hatala 50,
52; RMN, Hervé Lewandowski 14; RMN, R.G. Ojeda 17, 20, 61;
The Saint Louis Art Museum 16; Staten Museum for Kunst,
Copenhagen, Dowic fotografi *frontis.* (left), 5; The State
Hermitage Museum, St Petersburg 19, 26, 30; The State
Pushkin Museum of Fine Arts, Moscow 23, 41; Tate Photography,
London 28, 42

as born opposites, ironically this actually seems to have contributed to their sense of underlying affinity.

Against such a background of prolonged and intense, if often covert and competitive dialogue, it is not surprising that a sense of identification gradually developed. So, in the midst of a sleepless night, on 8 September 1947 Matisse wrote to Picasso to urge him to paint the murals that he himself was too old and infirm to execute:

> Tonight I feel totally convinced that Picasso should paint a true fresco in the museum at Antibes . . . I'm sure you will do something stunning and do it very simply. I want you to do this work because it's impossible for me to do it – and you will do it better than I could. Please think about it. It is important for everyone. Excuse me for insisting, but it is my duty.[3]

Summarising the bond between them that had developed over the years, Picasso told their mutual friend, André Verdet: 'Matisse knows that it is impossible for me not to think of him. Between him and me there is our common work for painting, and when all is said and done that unites us.'[4]

Physically, Matisse and Picasso were not in the least alike, and made very different impressions on those who knew them. Fernande Olivier, Picasso's lover at the time the two artists first met, draws a vivid contrast in her book of memoirs:

> There was nothing especially attractive about him [Picasso] at first sight, though his oddly insistent expression compelled one's attention. It would have been practically impossible to place him socially, but his radiance, an inner fire one sensed in him, gave him a sort of magnetism . . . Picasso was small, dark, thick-set, worried and worrying, with gloomy, deep, penetrating

eyes, which were curiously still. His gestures were awkward, he had the hands of a woman and was badly dressed and untidy. A thick lock of shiny black hair gashed his intelligent, stubborn forehead. His clothes were half-bohemian, half-workman, and his excessively long hair swept the collar of his tired jacket.[5]
> . . .
> There was something very sympathetic about Matisse. With his regular features and his thick, golden beard, he really looked like a grand old man of art. He seemed to be hiding, though, behind his thick spectacles, and his expression was opaque, gave nothing away, though he always talked for ages as soon as the conversation moved on to painting. He would argue, assert and endeavour to persuade. He had an astonishing lucidity of mind: precise, concise and intelligent. I think he was a good deal less simple than he liked to appear.[6]

According to Fernande, it was the 'serious and cautious' Matisse who was responsible for the famous remark that he and Picasso were 'as different as the North Pole is from the South Pole'.[7]

Matisse maintained his professorial appearance into old age, to the surprise of strangers who expected some outward sign of the notorious *fauve* (wild beast). With hair and beard neatly trimmed, often dressed in a perfectly cut suit, he worked in an orderly and well-swept, if not pristine environment, surrounded by the much-loved objects and fabrics that were the stuff of many paintings (fig.1). His appetite for talking and writing about his work, and his lucidity when doing so, suffered no decline; his collection of writings *Matisse on Art* is a substantial volume, the cornerstone of any study of his work.[8] His private life, on the other

hand, remained just that, with all the family skeletons kept firmly locked in the cupboard. Picasso, by contrast, stuck to his artisan-bohemian style of dress for most of his life, refused to keep similar hours to the rest of the world, and thrived in an atmosphere of chaos and jumble, in studios jammed with stacks of pictures, sculptures dumped unceremoniously wherever there was space, the floor strewn with cigarette butts, torn paper, pots of paint and dried-out brushes (figs.2, 43). Casual love affairs continue to come to light, complicating the already complicated story of his long-term relationships with women, and he allowed a remarkable degree of intrusion into his private life. During the 1950s, like the Hollywood film stars who hovered round him in the south of France, he became the centre of a media circus and quite literally a household name. On the other hand, he detested theorising about art and did his best to avoid explaining his work or his intentions; *Picasso on Art* consists not of his written texts but of reports of what he said, and the sayings were often contradictory or inconsistent.[9] Both artists, one might argue, erected useful smoke screens between themselves and the outside world, the difference being that Matisse was forthcoming about his artistic motivation and secretive about his life, whereas in Picasso's case it was the other way round.

The two painters came from very different backgrounds, the one from the chilly, rainy, cloudy north of France, not far from the Belgian border, the other from hot, dry, sunny southern Spain. Born on 31 December 1869 in Le Cateau-Cambrésis, Matisse was the son of a hardware and seed merchant. The family ethic was hard work and endurance, and as the eldest son Henri was expected to follow a solid profession with good financial prospects and some social cachet, preferably

the law. When he announced that he wanted to study painting his father was at first outraged and uncomprehending, and Matisse was already in his mid-twenties before he at last won a place at the Ecole des Beaux-Arts in Paris. He did not leave until he turned thirty. In the meantime, he had acquired significant responsibilities: by 1900 he was a married man with three children. The early part of his career as a painter was beset by pressing financial problems and it was also clouded by ruinous public scandals in which his own and his wife's families were implicated.[10] The need not merely to make a decent living to support all his dependents, but to present a respectable facade to the world and to guard his family's privacy, helps to explain the dignified, middle-aged demeanour of Matisse in his thirties, the wariness and suspicion with which he habitually regarded new acquaintances, and his reluctance to form intimate relationships. With Picasso, himself a rapid *tutoyeur*, Matisse never used the informal *tu*. Fernande Olivier's observation that Matisse was 'opaque' and 'a good deal less simple than he liked to appear' is very shrewd, for Matisse's outward calm and self-confidence were a front masking acute anxiety, agitation and, as he admitted privately, fear – feelings that made him a lifelong victim of insomnia. In being an 'unquiet soul', Matisse was in fact a lot more like Picasso than appeared – another, more obscure source of their sense of affinity.

Comparatively speaking, Picasso's path was smooth. Born on 25 October 1881 in Málaga, he was the eldest child of a painter who supplemented his income by teaching drawing. Far from opposing his son's vocation, Picasso's father made every effort to nurture and promote it. The boy was so precocious that by the age of fifteen he had not only been

1
Matisse's apartment at 1, place Charles-Félix, Nice 1926. Archives Matisse, Paris

2
Self-portrait by Picasso in his studio in rue Schoelcher, Paris 1915–16. Archives Picasso, Paris

accepted at Spain's top art school, the Royal Academy in Madrid, but already won prizes for huge moralistic narrative paintings executed under his father's guidance. Picasso might be 'worried and worrying', in Fernande's words, but the dazzling virtuosity for which he later became renowned had a foundation of supreme confidence, itself founded on the remarkable successes of his youth and his parents' unwavering belief in his genius.

Despite the twelve year difference in their ages, then, Matisse and Picasso trained to be painters simultaneously during the 1890s, and the training they received was essentially the same: indoctrination into the classical tradition alongside intensive study of the nude model. For both, in accordance with academic teaching, the human figure would ever afterwards remain the core subject. For both, moreover, Impressionist naturalism and the various abstracted and primitivising styles of the Post-Impressionists and Symbolists represented the avant-garde. As they grew older, the salient differences in their tastes and attitudes came to seem less and less significant to them: the younger generation worshipped false gods, whereas they shared fundamentally the same values.

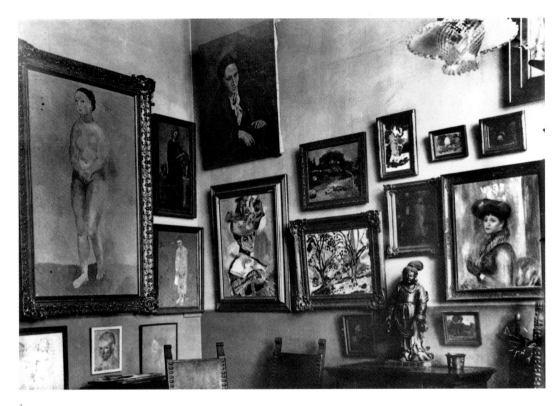

3
The studio of Gertrude and
Leo Stein at no.27 rue de
Fleurus, Paris, c.1907. Baltimore
Museum of Art

The Dialogue Commences

It is not known for sure when Matisse and Picasso first met. Picasso's visits to Paris in 1900–3, and his decision to settle in the artists' colony in Montmartre nicknamed the Bateau-Lavoir (laundry barge) in 1904, meant that they had an ever increasing number of acquaintances in common – dealers such as Ambroise Vollard and Berthe Weill, who bought and exhibited work by both, and critics including Paul Gauguin's friend Charles Morice, who wrote favourably about them both in the prestigious *Mercure de France*.[11] Their first meeting is often said to have taken place in the rue de Fleurus apartment of the audacious brother and sister team of collectors, Gertrude and Leo Stein. The Steins purchased works by both artists in 1905, including Matisse's astonishing portrait of his wife, *The Woman with the Hat* (1905, San Francisco Museum of Modern Art), which Leo bought despite thinking it 'the nastiest smear of paint I had ever seen' (it is visible beneath Gertrude's portrait in fig.3).[12] Possibly the meeting occurred in the wake of the furore over that picture and the other *fauve* paintings exhibited by Matisse and his followers in the Salon d'Automne of 1905;[13] possibly it occurred around the time of the Salon des Indépendants in March 1906, where *Le Bonheur de vivre* (fig.6) was Matisse's next *succès de scandale*. At all events, they must have been aware of each other's work before they met. Matisse may, for example, have seen Picasso's exhibition at Vollard's gallery in June–July

1901, which aroused critical comment because of the startling eclecticism and flair of the pictures on display. For his part, Picasso would have seen Matisse's one-man show in the same gallery in June 1904 and the substantial group of works exhibited at the Salon d'Automne later that year; he certainly would have observed Matisse's emergence as the most talked-about painter in Paris during the course of 1905. No wonder he became, in Olivier's words, 'sullen and inhibited' when *le roi des fauves*

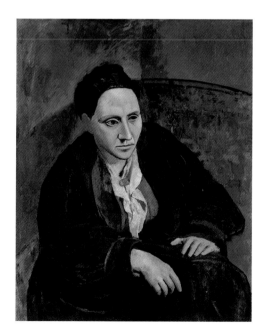

4
Picasso
Portrait of Gertrude Stein
1905–6
Oil on canvas 100 × 81.3 cm
The Metropolitan Museum of Art, New York. Bequest of Gertrude Stein, 1946

took the floor at the Steins' apartment and 'shone and impressed people' with his eloquent disquisitions on painting.[14] At this time – the winter of 1905–6 – Picasso spoke only rudimentary French and was not yet in Matisse's league.

Not long after his first meeting with the Steins, Picasso embarked on a portrait of the indomitable Gertrude (fig.4), who quickly identified him as a 'first class genius', an accolade she never bestowed on Matisse, and as 'her' painter and soul mate.[15] The portrait gave Picasso great trouble and it underwent several major revisions to the head before he was able to complete it to his satisfaction. Working from her posed before him eventually resulted in total stalemate: 'I can't see you any longer when I look', he complained, temporarily abandoning the unfinished picture in the spring of 1906.[16] There were no doubt several reasons for Picasso's indecisiveness, Stein's dominant personality being one, and another the need to produce something out of the ordinary to match the paintings by Henri de Toulouse Lautrec, Pierre-Auguste Renoir and especially Paul Cézanne lining the walls of her apartment. A third may have been the challenge offered by the dazzling colouristic fireworks and the slashing brushwork of Matisse's portrait of his wife in her outlandish hat, which arrived in the Steins' apartment at about the time Gertrude began posing for him. Picasso had used bold colour and an excessively sketchy technique in several of the paintings exhibited at Vollard's gallery in 1901, but they had none of the subtle balance or the luminosity of Matisse's rainbow harmonies, and their explosiveness was noisy rather than powerful. Since then Picasso had opted for an emphasis on firm contours and a simplified design, a restricted, tonal palette (first dark blues, later pastel pinks) and a more controlled kind of handling. It was in the

context of the fierce debates about 'the wild beasts' that Picasso settled on a rich but sombre brown-red palette for his portrait, and a composition indebted to the riveting *Portrait of Louis-François Bertin*, 1832 (Musée du Louvre, Paris), by Jean-Auguste-Dominique Ingres, famed as the upholder of the classical tradition in art.

Technical examination of *Portrait of Gertrude Stein* has revealed that Picasso had difficulty deciding upon the precise angle of the head and above all of the sitter's gaze: should she look the spectator in the eye or should she look away? His vacillation may have been compounded by Matisse's next portrait of his wife, known familiarly as *The Green Line* (fig.5). Matisse painted this in the latter part of 1905 and sold it to Michael and Sarah Stein, the brother and sister-in-law of Leo and Gertrude. (They became his devoted patrons from then on.)

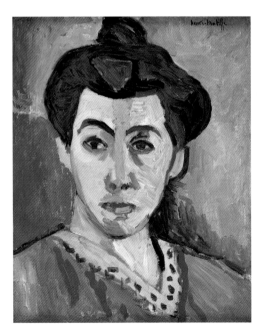

5
Matisse
Portrait of Madame Matisse ('The Green Line') 1905
Oil on canvas 60 × 41 cm
Statens Museum fur Kunst,
Copenhagen

Picasso would have seen it at their apartment at rue Madame and, one may presume, been taken aback by its daring candour and concentrated force. Compared to *The Woman with the Hat*, *The Green Line* is less flamboyant and more like an icon, with details of dress reduced to a minimum and the areas of colour that map out both head and background greatly simplified and reduced in number. The result is a sexless mask, hypnotic without being seductive, which suggests a person of considerable strength and firmness, but which is unrevealing about that person's inner life – or perhaps one should say, suggests that she is a closed book.

When Picasso repainted Gertrude Stein's head in her absence in the autumn of 1906 he treated it as an adamantine, helmeted mask, and gave the eyes a fixed remoteness not unlike that of Amélie Matisse in her husband's icon-portrait. It is true that Gertrude's mask is more sculptural, looming towards the overawed spectator, whereas Amélie is locked into the patterned background, and it is also true, as many writers have noted, that Gertrude's head resembles the ancient Iberian stone carvings that Picasso had recently discovered in the Louvre. However, it seems likely that if Picasso's portrait of Gertrude Stein was conceived (in part) in opposition to *The Woman with the Hat*, it developed (in part) in response to *The Green Line*. Significantly, when the two artists exchanged pictures in the autumn of 1907, Picasso chose one that is a more extreme, more rudimentary, more child-like variant of *The Green Line*, Matisse's *Portrait of Marguerite* (fig.17). In this the most daring aspects of the earlier painting have become, as it were, schematised. In the coming years, the inscrutable, distancing, generalising mask became part of the common currency of the figure paintings of both artists.

The Steins also made bold purchases among the subject pictures of Matisse and Picasso. Matisse's *Le Bonheur de vivre* (fig.6), bought soon after the spring Salon of 1906, must have been the single most eye-catching painting in rue de Fleurus, and represented the greatest challenge to Picasso as he began to attend the Steins' open-house Saturday parties. The brilliance and abstraction of the colour, the liberty of its calligraphy, the cavalier rejection of all current naturalist conventions for representing forms in space in favour of more 'primitive' systems of representation, had generated a critical furore and confirmed Matisse's position as the controversial leader of the avant -garde. Picasso must also have been aware of Matisse's seemingly effortless absorption and transformation of the Arcadian imagery of the great masters of the past, for *Le Bonheur de vivre* wears its pedigree on its sleeve, with its condensed allusions to Andrea Mantegna, Titian, Nicolas Poussin, and above all perhaps, the distorted nudes of Ingres (fig.14). *Boy Leading a Horse* (fig.7), completed in the spring of 1906 and also purchased for rue de Fleurus, represents Picasso's alternative to Matisse's pastoralism and makes creative use of a different raft of sources. Later, with *Les Demoiselles d'Avignon* (fig.12), Picasso would counter-attack in a more aggressive manner.

From the numerous studies that preceded it, we know that the extreme austerity of *Boy Leading a Horse* was attained only after a process of elimination. At one time Picasso contemplated a circus scene, at another a wide multi-figure composition of naked youths watering their horses at a river, with the walking boy and his horse at the centre. The references to the circus were stripped away because he was bent on purging his art of the sentimental charm and anecdotalism of his earlier saltimbanque imagery. The decision to abandon

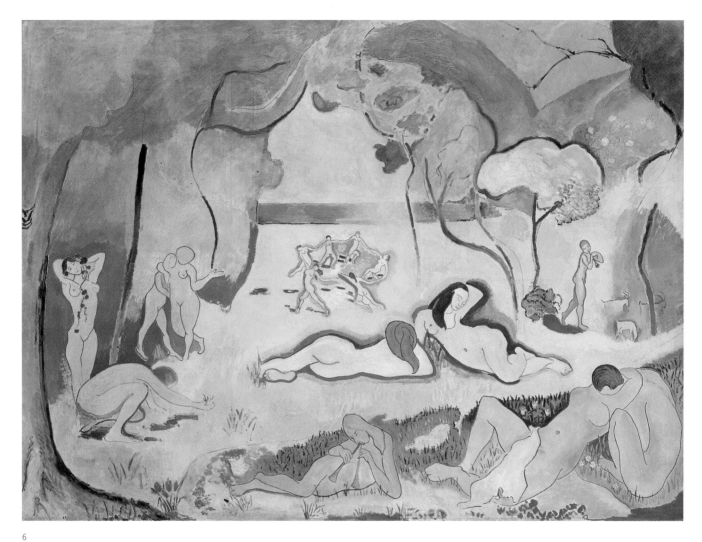

6
Matisse
Le Bonheur de vivre 1905–6
Oil on canvas 174 × 238 cm
The Barnes Foundation,
Merion Station, Pennsylvania

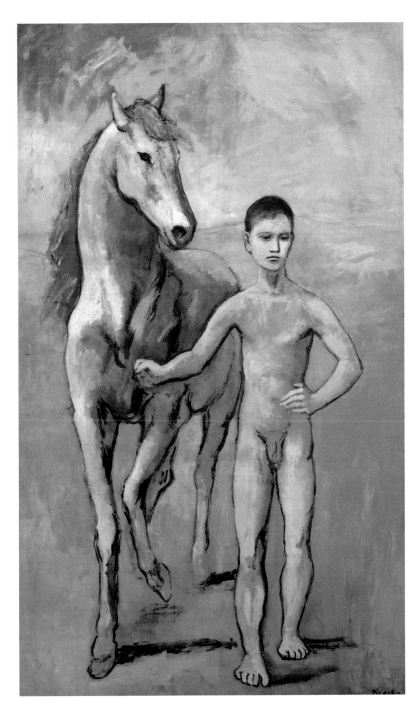

7
Picasso
Boy Leading a Horse 1906
Oil on canvas 220.6 × 131.2 cm
The Museum of Modern Art,
New York. The William S. Paley
Collection

the plan for the pastoral scene may have been partly prompted by the desire to put a distance between himself and the Matisse of *Le Bonheur de vivre*. At all events, Picasso's chaste, severe palette of terracottas and greys and the overcast sky of *Boy Leading a Horse* represent a calculated rejection of Fauve colour and dazzling sunlight, and the barren setting a rejection of its familiar symbols of fecund nature. The decision to reduce the scene to the archetypal pairing of athletic youth and horse, realised on the monumental scale of ancient Greek sculptures, suggests that he considered the figures in *Le Bonheur de vivre* too small and numerous and the composition overly episodic.

Within a matter of months of completing it, however, Picasso perhaps came to feel that *Boy Leading a Horse* was too deferential in its classicism and that his slim adolescent was no match for the muscular, striding Archaic Greek statues on which he had loosely based him. *Two Nudes* (fig.10), painted towards the end of 1906, is more monumental and impressive, suggesting that he had decided gracelessness, and ugliness, was the route to expressive drama independent of story-telling. Adapting the rigid mask of his portrait of Gertrude Stein and taking the squat bulk of her body as his model, he fashioned these awesome twins – or are they the same figure seen from two sides? – as if they were some ancient terracotta relief, increasing the impression of mass and size by reducing in all directions the extent of the surrounding space. Painting, he implies, will become truly powerful by way of the sculptural, not by way of the painterly.

We do not know what Matisse thought of these pictures, but it is unlikely he felt threatened by *Boy Leading a Horse*, which is more conventional in its drawing and modelling than the figure paintings of Cézanne – more conventional, for instance, than

the tough, energetically brushed little *Three Bathers* by Cézanne, which Matisse had owned since 1899 (fig.8). Picasso's *Two Nudes* was, however, another matter, for it represented a bold and compelling interpretation of Cézanne's monumental bathers as the distant progeny of the most 'primitive' ancient sculptures gathered in the Louvre. According to the Italian painter Ardengo Soffici, Picasso was often to be seen pacing around the galleries that housed the Egyptian, Chaldean and Assyrian antiquities 'like a hound in search of game'.[17] He channelled his discovery of the secret of their intimidating physical presence into *Two Nudes*. Matisse must also have spent time in the same galleries but *Le Bonheur de vivre* lacks the atavistic quality that makes Picasso's painting so redoubtable. The balance of power between the two painters was subtly shifting, and Picasso was emerging as an innovator to be reckoned with. That Matisse was indeed impressed by Picasso's 'archaic' nudes of autumn 1906 is suggested by developments in his work in 1907–8. There are, for instance, echoes of *Two Nudes* in the sculptural pair

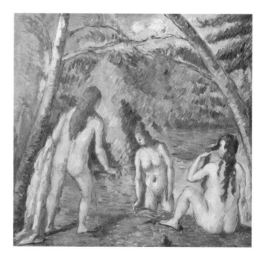

8
Paul Cézanne
Three Bathers 1879–82
Oil on canvas 52 × 55 cm
Musée de Petit Palais, Paris

9
Matisse
**Two Women (Two
Negresses)** 1908
Bronze 49.5 × 28 × 20 cm
Centre Georges Pompidou,
Paris. Musée National d'Art
Moderne/Centre de Création
Industrielle. Dation en 1991

10
Picasso
Two Nudes 1906
Oil on canvas 151.3 × 93 cm
The Museum of Modern Art,
New York. Gift of G. David
Thompson in honor of
Alfred H. Barr, Jr.

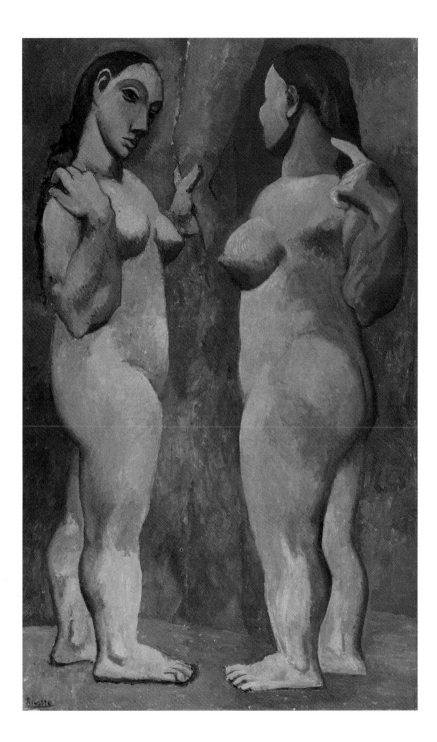

of massively built young women standing side by side, facing in opposite directions and staring fixedly at one another (fig.9), which Matisse modelled in the summer of 1907. And a more sculptural approach to form together with a commitment to awkward and 'ugly' large-scale figures are noticeable in some of Matisse's paintings of 1907–8, including *Bathers with a Turtle* (fig.16). For this development Picasso was, it seems, a catalyst.

Whenever they were both in Paris, Matisse and Picasso met quite regularly at the Steins'. According to Max Jacob, Picasso's great friend, they 'dined often at Matisse's home',[18] but the 'often' is probably an exaggeration. Two self-portraits (frontis-piece) invite speculation about their characters and their relationship at this critical moment. Matisse, heavily bearded, dressed in a sailor's striped jersey no doubt bought in Collioure, the fishing village where he painted the picture in the summer of 1906, looks with a mixture of defiance and appraisal, tinged with wariness, towards the spectator. Although the colours are strong, and saturated here and there, in this portrait Matisse paid more attention to creating an impression of three-dimensional mass through emphatic modelling, and to this end he significantly increased the size of the head, which is larger than life and dwarfs the shoulders. The impression given is of stubborn determination and confidence in the face of an untrustworthy, if not exactly hostile world. In his self-portrait, Picasso mesmerises the beholder with his dilated black gaze, the left pupil disconcertingly clouded, as if with a cataract, the right staring unremittingly. Like Matisse, he makes the head larger than life and places the dominant eye in the centre of the canvas to force attention on it. Unlike Matisse's fully modelled head, however, Picasso's resembles a mask and the gaze petrifies rather than assesses.

Painted in the spring of 1907, this self-portrait is contemporary with the revelation of what Picasso believed to be the true meaning of tribal sculpture. According to Matisse, it was thanks to him that Picasso first 'discovered Negro sculpture' in the autumn of 1906. On his way to see the Steins one day, Matisse had bought a small African carving of a seated man from a curio dealer in nearby rue de Rennes. Picasso happened to be there when he arrived and they studied it together.[19] But it was not until Picasso was confronted with the far more impressive carvings displayed in the ethnographic museum in Paris some six months later that tribal art made any significant impact on him. In conversation with André Malraux many years later, he remembered that first visit to the museum as a watershed:

> The masks weren't sculptures like other sculptures. Not at all. They were magical objects . . . The Negroes were intercessors . . . They were against everything; against unknown, dangerous spirits. I looked at those fetishes, and I realised that I too was against everything. I too believe that everything is unknown and hostile![20]

Picasso added that in reacting in this empathetic way to the magical properties and function of tribal art, he differed from his contemporaries, who were primarily responsive to its formal characteristics. Matisse, he said, discoursed about Egyptian art when he showed him his first Negro head.[21] Thrilled by his discovery, Picasso scoured the bric-à-brac shops and flea-markets for masks and 'fetishes', largely indifferent to their quality or provenance since it was their magic aura that most mattered to him. Soon his studio was bristling with them (fig.11). Matisse also collected *art nègre*, but less avidly and with more discrimination. There is nothing of the

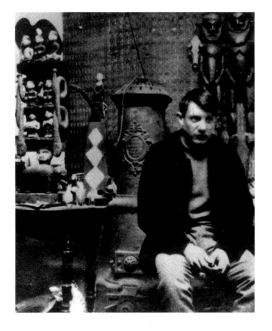

shaman about his forceful, uncouth self-image, whereas Picasso is in his newly assumed role as 'apprentice sorcerer', to borrow the label invented by his friend André Salmon.[22] Their contrasting interpretations of the alien source are, furthermore, entirely characteristic: time and again in his career Picasso embraced the irrational, excessive, shocking and dangerous in order to disturb the equanimity of the spectator, whereas Matisse shunned them as destructive of the precarious balance of his art.

Picasso's momentous visit to the ethnographic museum occurred while he was at work on *Les Demoiselles d'Avignon* (fig.12), and the impact of the 'fetishes' crammed into the musty, ill-lit galleries is registered in the forbidding mask-faces of the three women at left and right. These were areas of the painting that Picasso reworked, whereas he left the baleful but less grotesque Iberian-style heads

of the two central figures unchanged. In key respects the huge canvas appears to have been conceived in direct opposition to *Le Bonheur de vivre* (fig.6). It is, for instance, hard to imagine a less joyous, less relaxed, less life-affirming scene or a more airless, claustrophobic setting. Where everything in Matisse's painting is described in seductive arabesques, everything here is spiky and menacing; in place of the invitation to dream delicious dreams of guilt-free love, sexual desire and sensual pleasure, there is the frightening drama of the towering women's relentless confrontation – a confrontation that in the case of the squatting, red-faced figure seems defiantly furious and hostile. From the numerous preparatory sketches, we know that Picasso's original idea was for a brothel scene with five naked prostitutes surrounding a sailor, the archetypal client, and a doctor entering from the left to conduct a routine medical inspection. All that remains of that original plan is the core idea of the staged display of female flesh, and it is the spectator who has assumed the role of the client in this ominous stand-off; one is reminded of the predicament of the hermit St Anthony, tormented by visions of naked women. The moral gulf between this frightening vision of threatening sexuality and Matisse's delicious Arcadia is absolute.

That Matisse himself had independently decided to paint in a more sexually confrontational manner is clear from *Blue Nude: Memory of Biskra* (fig.13). The painting shocked spectators when it was shown in the spring Salon of 1907 because the nude was deemed horribly ugly and deformed,[23] and Matisse's style shockingly uncouth. The lifesize female nude reclining in an idealised landscape, ennobled with some appropriate mythological or literary pedigree, had long been a popular fixture in the Salons. But Matisse flouted the tacitly agreed

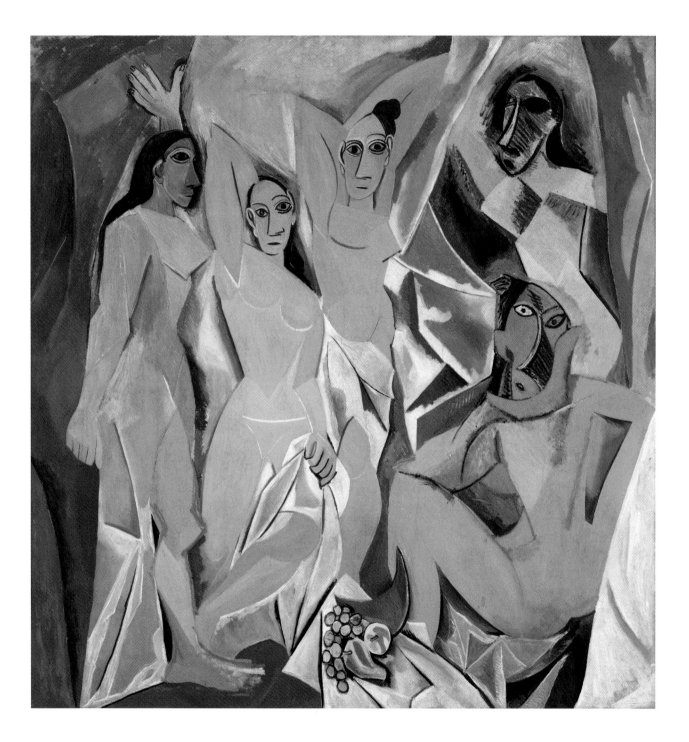

13
Matisse
Blue Nude: Memory of Biskra
1907
Oil on canvas 92.1 × 140.3 cm
The Baltimore Museum of Art:
The Cone Collection, formed
by Dr. Claribel Cone and
Miss Etta Cone

14
Jean-Auguste-Dominique Ingres
La Grande Odalisque 1814
Oil on canvas 91 × 162 cm
Musée du Louvre, Paris

Opposite 12
Picasso
Les Demoiselles d'Avignon
1907
Oil on canvas 243.9 × 233.7 cm
The Museum of Modern Art,
New York. Acquired through
the Lillie P. Bliss Bequest

rules of the game by refusing to paint a convention-
ally beautiful and passive feminine type and by
making his graceless, muscular and overbearing
'odalisque' tip and swivel towards the spectator,
so that although her eyes are modestly downcast,
her torso appears to stare boldly back, the nipples,
pupil-like, holding and answering the spectator's
gaze. *Blue Nude* was bought by Leo Stein. Within
a matter of months he and Gertrude had also
bought Picasso's *Nude with Drapery* (fig.15), which
has almost exactly the same format, but is oriented
vertically rather than horizontally. Picasso's
intention, one suspects, was to trump Matisse by
travestying the same conventional motif in an even
more radical style. He is on record as judging *Blue
Nude* a fatal compromise between the naturalistic
and the decorative, remarking to Walter Pach:
'If he [Matisse] wants to make a woman, let him
make a woman. If he wants to make a design, let
him make a design. This is between the two.'[24] In
Nude with Drapery he corrected Matisse's 'error' by
fusing figure and decor through his imposition of a
common pattern of hatching over virtually the entire
surface. This was a unique experiment at the time
and the style itself, inspired by the carving technique
and dog-tooth and basket-weave patterns of African
wooden reliefs, was a forthright demonstration of
his identification with the Negro sculptors.

Picasso later referred more than once to a
humiliating encounter with Matisse when the
latter came to see his new paintings with Leo Stein.
Nude with Drapery was already installed in the
Steins' apartment, but the unsold *Les Demoiselles
d'Avignon* was in his studio together with the huge,
still unfinished *Three Women* (1907–8, The State
Hermitage Museum, St Petersburg) and various other
sculptural figure paintings that synthesise the rough-
hewn style of Cézanne's Bather compositions with

15
Picasso
Nude with Drapery 1907
Oil on canvas 152 × 101 cm
The State Hermitage Museum,
St Petersburg

the conceptualised treatment of proportion and anatomy in African and Polynesian art. The flagrant primitivism of these paintings went beyond what anyone else was attempting at the time, and the expressionistic stridency of *Les Demoiselles d'Avignon* provoked almost universal revulsion whenever Picasso showed it to visitors. On the occasion in question, Matisse and Leo Stein burst out laughing and mocked Picasso's incoherent attempts to explain his intentions.[25] *Bathers with a Turtle* (fig.16) was painted early in 1908 and probably in the wake of this visit to Picasso's studio. It can be seen as Matisse's counter-attacking reply to what he considered the grotesque excesses of *Les Demoiselles d'Avignon*.

Like *Les Demoiselles*, *Bathers with a Turtle* originated in a modern life subject: bathers on a beach with sailing boats silhouetted against the calm expanse of sea behind. Like *Les Demoiselles*, the composition was stripped of all the mundane defining details, but in place of them Matisse introduced a fourth, surprising character – the turtle (or tortoise). It is the focus of the women's absorbed attention and each reacts differently, one, unafraid of the creature, squatting down to attract it to her by offering it a morsel of food, one watching it with intense interest, but warily and with evident reluctance to touch or be touched by it, the third responding emotionally with an indefinable mixture of wonder, dread and distress. The tortoise thus introduces a provocative element of mystery, raising the possibility of a mythological source for the subject and strongly suggesting that the symbolism is of a sexual nature.[26] The psychological drama, which turns on the protagonists' act of looking and reacting to what they see in ways that are not explained through narrative to the beholder, is equivalent to the unexplained emotional reactions expressed by the five women in *Les Demoiselles*

d'Avignon. The sense that Matisse has depicted a fallen world, the world of 'experience' not 'innocence', is a further link with Picasso's painting.

Everything about *Bathers with a Turtle* seems elemental as well as elementary – the Neanderthal aspect of the central figure, the schematic treatment of sky, sea, earth and flesh, the bold contrasts of colour and tone, the rough methods employed for laying on or scraping off the colour and affirming the contours, the unabashed traces of alteration to the composition. It is as if Matisse were intent on painting as if he had never learned to paint 'properly', and he went further in this respect than he had in *Blue Nude*. Like Picasso, he was evidently indebted to Cézanne's Bather compositions (and especially to the one he owned, fig.18). His other main source was the Italian 'primitives', and in particular Giotto's Arena Chapel cycle (completed *c.*1306) in Padua, which he had admired during a trip to Italy in the summer of 1907. The Italian frescoes supplant the tribal sculptures to which Picasso had turned for inspiration, and affirm Matisse's commitment, at this stage of his career, to the European tradition. It is this that makes *Bathers with a Turtle* look more like the paintings Picasso had executed before he experienced the revelation of *art nègre* in the spring of 1907 than those executed in its aftermath.

The relationship between the two painters had developed a sharp competitive edge by the spring of 1908. Gertrude Stein claims that they became 'enemies' as well as 'friends', and that Matisse was jealous both of her 'growing friendship' with Picasso and of Picasso's ascendancy within the Parisian avant-garde, as the new paintings of former Fauves (notably André Derain and Georges Braque) began to show his influence, rather than Matisse's.[27] Whilst there is probably some truth in

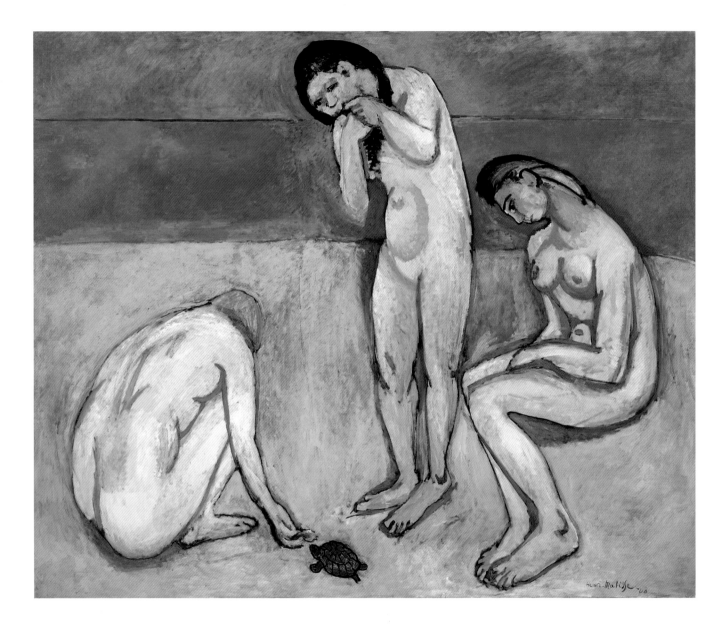

24

Opposite 16
Matisse
Bathers with a Turtle 1908
Oil on canvas 179 × 220 cm
The Saint Louis Art Museum.
Gift of Mr and Mrs Joseph
Pulitzer, Jr

her version of events, one needs to be aware that by the time she wrote her memoirs Stein had fallen out with Matisse and also that she was inveterately competitive herself, and thus prone to projection. She is, at all events, certainly wrong to suggest that when Matisse and Picasso exchanged paintings (figs.17, 18) in the autumn of 1907, they 'chose each one of the other the picture that was undoubtedly the least interesting either of them had done', with the intention of using it as proof of the other's 'weaknesses'.[28] Picasso later told John Richardson that he had always considered *Portrait of Marguerite* 'a key picture' in that it revealed with special clarity the influence on Matisse of his own children's paintings, which 'completely changed his style'.[29] Picasso must also have found this self-conscious naivety attractive since at the time of the exchange he too was fighting to attain the 'primitive', albeit by a quite different route. Towards the end of his life he was delighted when Pierre Daix noted the similarity between Marguerite's sideways nose and the noses of the Demoiselles: 'You're beginning to

know how to read painting,' he remarked. Pressing home the point, he went on: 'You've got to be able to picture side by side everything Matisse and I were doing at that time. No one has ever looked at Matisse's painting more carefully than I; and no one has looked at mine more carefully than he.'[30] For his part, Matisse must have responded to the Cézannesque aspects and to the ruggedly sculptural conception of form in Picasso's *Pitcher, Bowl and Lemon*. The exchange pictures may be diametrically opposed in style but they embody values that their new owners understood and appreciated. Gertrude Stein's account of the Matisse–Picasso relationship at this point is further called into question by the generous action of Matisse in bringing one of his most important patrons, the Moscow businessman Sergei Shchukin, to Picasso's studio in the autumn of 1908. Shchukin instantly bought two large pictures and went on to purchase many more over the next few years. Matisse was thus instrumental in helping Picasso escape the grinding poverty of his early years in Paris.

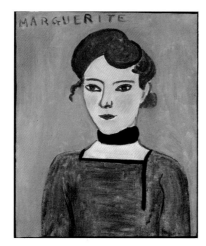

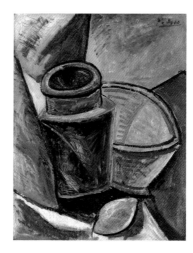

17
Matisse
Portrait of Marguerite 1906
Oil on canvas 65 × 54 cm
Musée Picasso, Paris

18
Picasso
Pitcher, Bowl and Lemon 1907
Oil on wood 63.5 × 49.5 cm
Private collection, courtesy
Beyeler Foundation,
Riehen/Basel

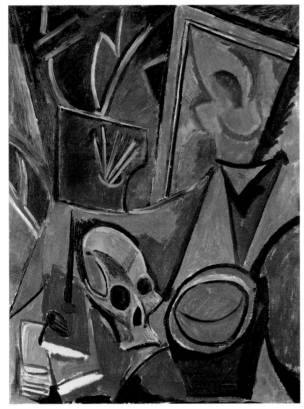

19
Picasso
Still Life with a Skull 1908
Oil on canvas 115 × 88 cm
The State Hermitage Museum,
St Petersburg

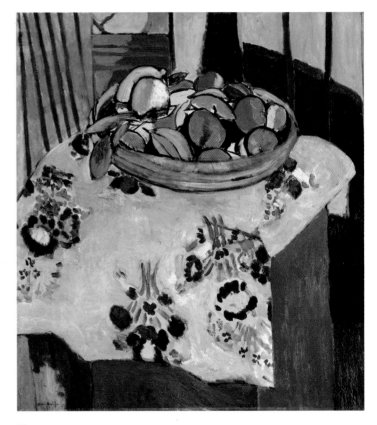

20
Matisse
**Still Life with Basket of
Oranges** 1912
Oil on canvas 94 × 83 cm
Musée Picasso, Paris

Four Still Lifes

Matisse and Picasso were in agreement that the single most important subject for the artist was the human figure. Except in the case of portraiture, in practice to them this meant the female figure. They would also have agreed that the modern artist must eschew 'literary' subject matter and dramatic narrative, hence the strategies they adopted to strip their iconography of all inessential details and so render it purely suggestive rather than illustrative. As Matisse wrote in 'Notes of a Painter', his best-known essay about his work, which was published in December 1908:

> What I am after, above all, is expression . . . Expression, for me, does not reside in passions glowing in a human face or manifested by violent movement. The entire arrangement of my picture is expressive: the place occupied by the figures, the empty spaces around them, the proportions, everything has its share.'[31]

When it came to the role assigned to the setting, however, Matisse and Picasso differed noticeably. Whereas Picasso, true to his essentially classical and sculptural vision, tended to place the figure at the centre and make everything else subsidiary to it, Matisse, as he implies in the statement above, treated the figure as a co-ordinate in the entire visual field. Given this difference, it comes as no surprise that Matisse was much more of a land-scape painter than Picasso, the furnished interior acting as the domestic equivalent of the outdoor landscape, with the window, as intermediary between indoors and outdoors, being a privileged motif. Apart from the figure, the other subject to which both artists were equally devoted was still life, as Matisse indicated when he took *Pitcher, Bowl and Lemon* in return for the portrait of his beloved only daughter, and as Picasso indicated when he acquired Matisse's *Still Life with Basket of Oranges* (fig.20) in 1942.

A comparison between the resplendent *Basket of Oranges* and Picasso's *Still Life with a Skull* of early 1908 (fig.19) brings into focus typical differences of vision and method. *Still Life with a Skull* is in the venerable tradition of the *memento mori* – a genre popular in Spain since the seventeenth century and explored memorably by Cézanne in a series of late paintings depicting skulls. During his Symbolist period from the late 1890s until he settled in Paris in 1904 Picasso had been preoccupied with representations of sickness and death, and he realised that the still-life genre would allow him to explore these themes in a non-narrative manner. *Still Life with a Skull* is simultaneously an essay in symbolic autobiography, the palette and brushes referring to Picasso the painter, the pipe balanced on the books to Picasso the man. The framed picture of the nude in the background seems, like the upturned palette, to be propped against a larger and darker painting of a landscape, a reference to the bather paintings

Picasso was creating at this time in emulation of Cézanne. The female nude also signifies woman-kind and by extension both sexuality and life, so that her position adjoining, but divided from, the palette and in line with, but divided from, the skull is clearly significant. The dramatic tension between these opposites, male–female, artist–subject, interior –exterior, life–death, is exacerbated by the restless rhythm of a composition split into competing parts and built from sharply angled wedges suggestive of shattered forms, by the extreme compression and congestion of the space, and by the discord between bright spectrum colours and brooding earth tones. The sense of fateful drama connects the painting directly to *Les Demoiselles d'Avignon* (fig.12), and in early studies for that picture the doctor entering the brothel carried a skull as if to warn us that the wages of sin are death.

By contrast Matisse's *Basket of Oranges* presents the beholder with ravishing proof of the beauty and plenitude of nature, and although a process of sublimation is involved, this is achieved without recourse to allegory or symbolism. It was painted soon after Matisse's arrival in Tangier at the end of January 1912 and reflects his enthralled response to the profusion of oranges and lemons and richly patterned textiles on sale in the markets, and to the quality of Moroccan light. Yet, translating his pleasure into paint on canvas was anything but easy. In a postcard to Gertrude Stein of 16 March 1912, Matisse wearily complained: 'Painting is always so difficult for me. It's always a struggle. Is that normal? Yes, but why should it be so hard? It's so lovely when it comes naturally.'[32] He may have been thinking specifically of *Basket of Oranges* which, as we know from several rapid drawings recording different states of the composition and from technical examination, went through significant changes. The process of sublimation was clearly arduous, but the spectator barely notices this because the subject matter is deceptively simple, the overall harmony of the composition so unforced and the colour so glorious that it dispels any suspicion of the artist's frustration.

Picasso loved and revered *Basket of Oranges* . Wishing to honour its creator, in October 1944 he lent it to the Salon marking the end of the German occupation of Paris in which he was being honoured with a retrospective of his wartime work. 'Matisse is a magician, his use of colour is uncanny', he remarked enviously to Françoise Gilot as they emerged from the Salon d'Automne of 1945, where Matisse was the subject of an equivalent retrospective.[33] But it was also Matisse's commitment to celebrating '*bonheur de vivre*', however much it cost him to do so, that attracted Picasso as the necessary antidote to his own tragic vision of the world. During the dark days of the Occupation, his cold studio lit up and warmed by the glow of the Tangier still life, Picasso's admiration grew to the point where Matisse seemed to him to be in a class of his own. 'All things considered, there is only Matisse', became a kind of refrain.[34]

Comparison between two still lifes completed during the Occupation reveals a similar pattern of difference in artistic vision. Picasso painted *Still Life with a Sausage* (fig.21) in Paris in May 1941, and although the table is laden with food and wine, the combination of gloomy lighting, colourless palette, claustrophobic space and vicious butcher's knife conjures up a torture chamber rather than a convivial meal. In the mind's eye, the coil of sausage is transformed into a human gut, the artichokes into severed hands. Sanctioning a symbolic reading, Picasso himself compared the knives and forks sticking up in the open drawer to 'souls in

21
Picasso
Still Life with a Sausage 1941
Oil on canvas 92.7 × 66 cm
Collection of Tony and Gail Ganz

22
Matisse
Still Life with a Magnolia 1941
Oil on canvas 74 × 101 cm
Centre Georges Pompidou,
Paris. Musée National d'Art
Moderne/Centre de Création
Industrielle, Paris. Achat en 1945

'purgatory' and likened the general atmosphere to the 'dark and dismal' regime of Philip II of Spain.[35] Throughout the Occupation, Picasso continued to produce still lifes that alluded symbolically to the unfolding tragedy; the skull was a recurrent motif, sometimes allied with leeks arranged to resemble crossbones.

Matisse's lot during the Occupation was very different. In the South of France he suffered less from fear of Nazi persecution or the shortages of basic necessities that made life in Paris alarming and miserable, but he was cut off from its thriving and stimulating underground cultural activity

and his own life hung in the balance. Cancer was diagnosed early in 1941 and for a time it looked as if he would not survive his operation; he did survive but was left greatly and permanently weakened. *Still Life with a Magnolia* (fig.22), completed in December 1941 celebrates his 'resurrection' and Matisse came to regard it as one of his very best pictures because he had pushed himself to the limits in creating it.[36] The sense of a will to sublimate is more pronounced than in *Basket of Oranges* because the style is so simplified that the relatively thinly brushed objects suspended against the glorious, saturated red ground seem transparent

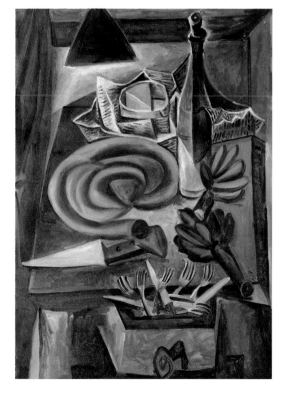

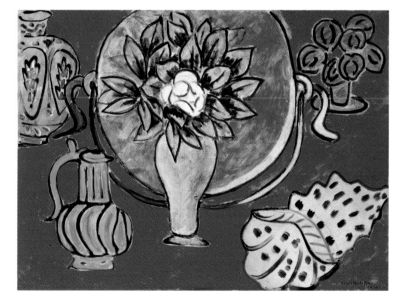

and dematerialised; the hieratic arrangement of the jar, copper cauldron, plant, shell and jug encircling the vase of magnolia reminds one of planetary movement around the sun, or, as some critics have suggested, an altarpiece in which the Virgin and Child and attendant Saints have been replaced by their emblems. If Picasso's table-top still life is hellish, this one is its heavenly antidote. Ironically, however, it took Matisse far longer to arrive at this seemingly naive statement of faith in creativity than it took Picasso to paint his torture chamber, a struggle that can be traced in the photographs showing the successive states through which the painting went before Matisse judged he had got somewhere close to realising his 'dream' of a 'soothing, calming . . . art of balance, of purity and serenity'.[37]

The Cubist Years

In July 1909 Matisse had taken out the lease on a house in Issy-les-Moulineaux, a southwestern suburb of Paris, and erected a studio in the garden large enough to accommodate the huge decorations Shchukin had commissioned him to paint, the *Dance* and *Music* murals (1909–10) now in the Hermitage Museum in St Petersburg. His contact with Picasso became more irregular and it was around this time that their paths as artists diverged

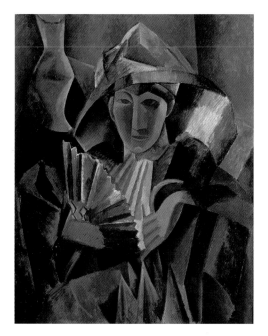

23
Picasso
Woman with a Fan 1909
Oil on canvas 100 × 81 cm
The State Pushkin Museum of
Fine Arts, Moscow

markedly. Matisse had opened an 'Academy' in January 1908 and by the time he moved to Issy he had attracted a band of devoted students, most of them foreign. Matisse the esteemed Master must have been a much less sympathetic figure in Picasso's eyes than Matisse the embattled Fauve. In any case, by 1909 Picasso was deeply absorbed in his own adventure – the development of 'Analytical' Cubism, with Braque as his partner. *Woman with a Fan* (fig.23), painted in the spring of that year, is still an easily decipherable image, but the emphasis on the underlying geometry of all the structures depicted, the fragmentation of the lower torso, the tendency to merge the figure with the surrounding space, and the restriction of the palette and reliance on arbitrary shifts in tone anticipate the extreme abstraction of Picasso's Cubist paintings of 1910–11. *Interior with Aubergines* (fig.25) and *The Red Studio* (fig.24), both painted during 1911, demonstrate the entirely different trajectory of Matisse's work as his love affair with Islamic decorative art and Persian miniatures bore fruit.

The first signs of the renewal of their dialogue can be dated to the autumn of 1912, and it was Picasso who made the first move. Picasso and Braque had spent most of the summer working alongside each other in Sorgues, near Avignon. That September, Braque made a decisive break-through when he began to incorporate strips of wallpaper printed with a woodgrain design into his

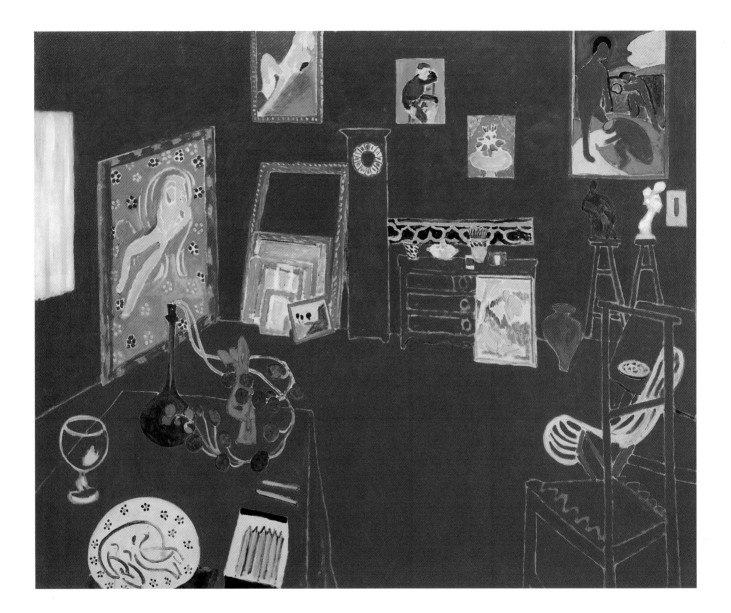

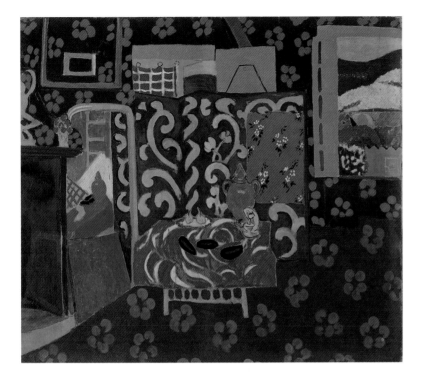

25
Matisse
Interior with Aubergines 1911
Distemper on canvas
212 × 246 cm
Musée de Grenoble. Gift of
the artist, in the name of his
family. Formerly collection
Michael and Sarah Stein

Opposite 24
Matisse
The Red Studio 1911
Oil on canvas 181 × 219.1 cm
The Museum of Modern Art,
New York. Mrs Simon
Guggenheim Fund

drawings: he had invented the revolutionary *papier colle* technique. Back in Paris in October 1912, Picasso began to turn out *papiers collés* himself, delighted by the flexibility and informality of the medium, which perfectly complemented his own experiments with collage earlier in the year, when he had incorporated a piece of oilcloth printed with a chair-cane pattern into a small oval still life. His first relief constructions assembled from cardboard, coloured paper and string also date from the autumn of 1912 and are like three-dimensional, 'pop-up' versions of his *papiers collés* (see fig.43).

From the first, Picasso (unlike Braque) used a variety of decorative wallpapers and borders, as well as plain papers and newspaper, revelling in the opportunity to introduce positive colour and pattern into the hitherto austere language of Cubism. In doing so Picasso trespassed on territory associated in everyone's mind with Matisse, and it has been pointed out that several of his *papiers collés* of 1912–13 have much in common with *Interior with Aubergines*, which Matisse had exhibited in the Salon d'Automne of 1911.[38] In *Guitar* (fig.27), for example, Picasso used a patterned wallpaper that is similar to the fabric stretched over the screen in *Interior with Aubergines*, and his method of splitting, locking together and dispersing the cut-out shapes over the underlying grid is reminiscent of the devices that Matisse used to unify and order his variegated composition. Meanwhile Picasso's employment of a strong blue paper for the ground of *Guitar* acknowledges the space-creating coloured grounds of paintings such as *The Red Studio* and *Goldfish and Sculpture* of 1912 (The Museum of Modern Art, New York), one of several paintings with a bright blue ground. By contrast, the sculptural, thrusting, centralised forms of *Table with Violin and Glasses* (fig.26), which derives directly from Picasso's contemporary cardboard reliefs, can be seen as anti-Matissean. Yet even this picture has a Matissean element: the bold patterned border cheekily echoing the scroll and f-holes of the violin and stretching from side to side of the canvas. The same might be said of the pretend-moulding of the dado and the real upholstery fringe incorporated into the small wooden wall relief that Picasso constructed in the spring of 1914 (fig.28). The *papier collé* technique soon affected Picasso's contemporary Cubist painting, which became so colourful and ornate in 1914–15 that it has been dubbed 'rococo'. *Portrait of a Young Girl* (fig.29) painted in the summer of 1914, is an exuberant and witty tour de force in this mode and is like a Matisse decorative interior reassembled, patchwork-fashion, as a

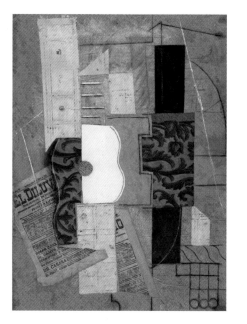

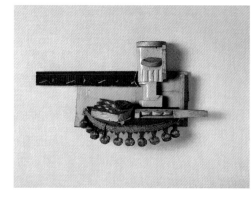

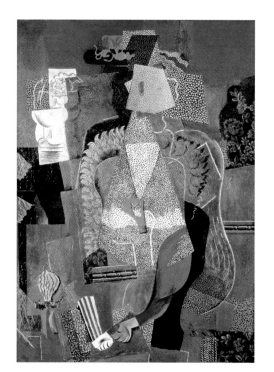

26
Picasso
Table with Violin and Glasses
1913
Oil on canvas 65 × 54 cm
The State Hermitage Museum,
St Petersburg

27
Picasso
Guitar 1913
Pasted paper, charcoal,
ink and chalk on blue paper,
mounted on ragboard
66.4 × 49.6 cm
The Museum of Modern Art,
New York. Nelson A.
Rockefeller Bequest

28
Picasso
Still Life 1914
Painted wood and upholstery
fringe 25.4 × 45.7 × 9.2 cm
Tate. Purchased 1969

29
Picasso
Portrait of a Young Girl 1914
Oil on canvas 130 × 96.5 cm
Centre Georges Pompidou,
Paris. Musée National d'Art
Moderne/Centre de Création
Industrielle. Legs de Georges
Salles (Paris) en 1967

figure. The vignettes of fruit-bowl, marble fireplace and flowery wallpaper, like the various elements of the girl's elaborate costume, correspond to the paintings and other works of art dispersed throughout *The Red Studio*. The intense green ground on which all the competing patterns are arranged is another obvious borrowing from Matisse's repertoire.

Meanwhile, symmetrically, Matisse had begun to take a serious interest in Cubism. Now that the style had entered its 'Synthetic' phase, it shared common ground with his work and was more attractive and meaningful to him. It was also clear that Cubism would not go away, that in Matisse's own phrase it represented 'modern construction',[39] and any adventurous, ambitious artist was bound to try to come to terms with it in one way or another. Matisse's new openness to Cubism had a personal dimension, for his friendship with Picasso had become closer during the course of 1913. So, when Picasso was ill that July, Matisse came often to ask after him and visited at length when he was better; in August they went riding together in the woods near Issy – to the amazement of mutual friends who had never seen Picasso on a horse.[40] Recalling this period later, Matisse said:

> Shortly before the war, in 1912 or 1913, our differences were amicable. Sometimes our points of view were curiously convergent. Picasso and I were at ease with one another. We gave each other a great deal in our exchanges. We were passionately interested in our respective technical problems. We undoubtedly benefited from one another. I think that ultimately there was mutual interpenetration of our individual approaches. This, it should be emphasised, was the time when discoveries by one or other of us were offered generously to all, a time of artistic brotherhood.[41]

As Matisse acknowledged in the same conversation, his growing friendship with Juan Gris, who considered Picasso his mentor, was another factor in this 'convergence'.

A painting that registers the beginning of this change is the majestic and haunting *Portrait of Mme Matisse* (fig.30). It required scores of sittings and in the process the figure increased significantly in scale and became more abstracted and impersonal, to the keen distress of the sitter, who wept to see her likeness disappear.[42] A weary, unsmiling Amélie Matisse, leaning slightly forward and seated in the same wicker armchair, appears in a photograph taken in Issy in May 1913.[43] Matisse stands beside her, dressed for work, and behind them is the huge, still unfinished *Bathers by a River* (1916, Chicago Art Institute), on which he worked simultaneously that summer (fig.31). The photograph suggests that Madame Matisse posed for her portrait in front of *Bathers by a River* and that the rich blue background may cover indications of the foliage and water in that picture. At all events, the luxuriant blues and emerald greens, while openly alluding to Cézanne, the guiding-spirit behind the portrait, evoke a shady, outdoor setting, and Madame Matisse appears, improbably, to be both fashionable bourgeoise and presiding divinity of nature. Her superhuman aspect is established primarily by the whitened, African-style mask that has obliterated her features and rendered the real woman unknowable and unapproachable, although benign. One is reminded of the masked faces of Picasso's *Gertrude Stein* (fig.4) and *Woman with a Fan* (fig.23), but in both those cases the eyes look and see, whereas in Matisse's painting they are black cavities. Comparison with *Woman with a Fan* suggests, furthermore, that Matisse had become interested in the limited colour schemes, geometry

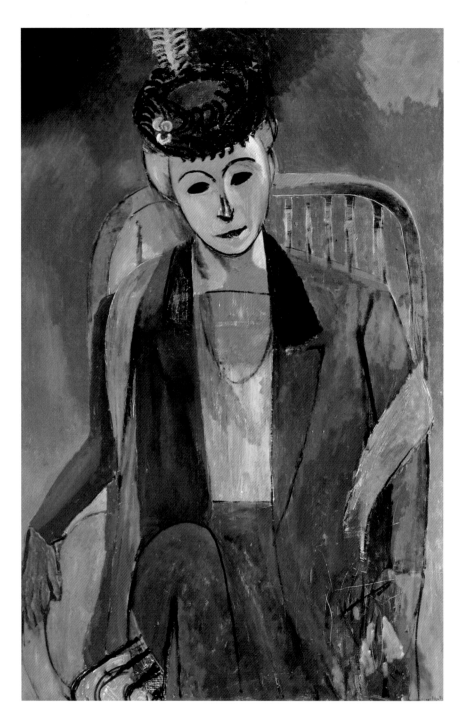

30
Matisse
Portrait of Madame Matisse
1913
Oil on canvas 146 × 97.7 cm
The State Hermitage Museum,
St Petersburg

31
Alvin Langdon Coburn, **Matisse
and Mme Matisse in the studio
at Issy les Moulineaux**, May
1913, The Museum of Modern
Art, New York

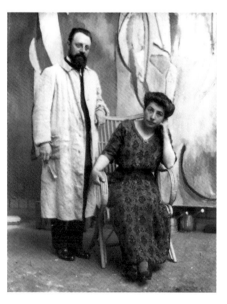

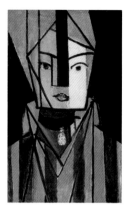

32
Matisse
White and Pink Head 1914–15
Oil on canvas 75 × 47 cm
Centre Georges Pompidou,
Pairs. Musée National d'Art
Moderne/Centre de Création
Industrielle, Paris

and elisions of early 'Analytical' Cubism, which, as he well knew, was deeply influenced by the very Cézannes that had most influenced him. But what makes the on-going exchange between Matisse and Picasso at this critical moment particularly fascinating is its reciprocal nature. When Picasso went riding with Matisse in August 1913, *Portrait of Mme Matisse* was still unfinished and he must have seen it in the Issy studio; he would also have seen it finished when it was exhibited in the Salon d'Automne a few months later. One may not, therefore, be deluded if one detects certain teasing allusions to its iconography in Picasso's *Portrait of a Young Girl* of summer 1914 (fig.29) – the fancy hat, the elusive mask-face, the encircling stole, the paw-hands.

In a letter to Charles Camoin of November 1913, Matisse noted that his portrait of his wife had been well received in the Salon, but added gloomily: 'it hardly satisfies me; it is only the beginning of an agonising effort.'[44] He was no doubt anticipating the self-imposed task of coming to terms with Cubism. *White and Pink Head* of autumn 1914 (fig.32), for which his daughter Marguerite posed, is perhaps the most candid testament to that ultimately rewarding and invigorating endeavour. Here, the simplified geometric planes, clarified grids and minimalist identifying 'signs' of 'Synthetic' Cubism are imitated in a fashion that might be thought caricatural were it not for the evidence on the impasted surface of Matisse's dogged, courageous labour. Within a couple of years his 'agonising effort' would bear fruit in magnificent portraits in which the lessons of Cubism are fully integrated and there is no whiff of pastiche.

As we know from Greta Prozor herself, her portrait (fig.33) was completed after she had ceased to pose for Matisse and, as we know from photographs of earlier states (fig.34), it became more

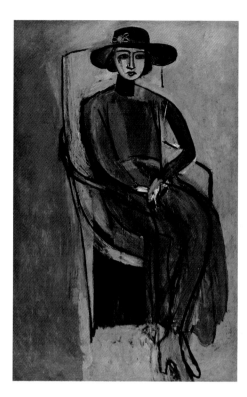

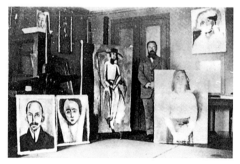

33
Matisse
Portrait of Greta Prozor 1916
Oil on canvas 146 × 96 cm
Centre Georges Pompidou,
Paris. Musée National d'Art
Moderne/Centre de Création
Industrielle. Don de la Scaler
Foundation (Houston, Texas,
Etats Unis) en 1982

34
Matisse at quai Saint-Michel
with his portrait of Greta
Prozor before completion,
and other works 1916.
Photograph courtesy
The Museum of Modern
Art, New York

sombre in costume, colour and mood, under the impact perhaps of the appalling news of the carnage on the battlefields of France.[45] Here Matisse succeeded in resolving the conflict between his reading of Cubist geometry and his engagement with the European tradition of the formal, full-length portrait. As in the portrait of Amélie Matisse, indications of the sitter's unique looks, personality and inner life have been largely eradicated. Greta Prozor was an actress who moved in the same circles as Matisse and Picasso during the war and was admired for her expressive readings of avant-garde poetry, but in her portrait her face has set into a mask and her pose is undemonstrative and standardised. Nevertheless, the sense of a forceful presence comes across; indeed, floating in her golden throne against the gold and pewter background, she seems almost deified. The drama and theatricality associated with her have been, as it were, subsumed within the aesthetic drama of Matisse's battle to create a harmonious, integrated composition, for there is a riveting tension between the stock-still, brooding figure and the intense physical energy of the artist's technique.

Goldfish and Palette (fig.35) is contemporary with White and Pink Head and belongs to the earlier, more experimental phase of Matisse's dialogue with Cubism. It too went through major changes, which, to judge from the signs of repeated scraping back and over-painting, involved a sometimes exasperating struggle. Yet the result is majestic as well as exciting and moving. Again, one is reminded strongly of Cubist papier collé (fig.27), although the subject of a still life before a window and the motif of goldfish are very much Matisse's own. The process of abstraction led to the virtual elimination of the figure of the artist, seated on the right, who was perfectly recognisable in Matisse's rapid sketch of the composition in its first state. Depicting the artist working from nature may have come to seem absurd and false to him as he moved ever further towards a conceptual rendition of the subject and replaced relatively lifelike descriptions of the individual objects, the spaces of the room and the fall of light with highly abstracted 'signs'. He did, however, leave the artist's palette, with the ghostly indication of his thumb, as an emblem of the painter's activity.

Goldfish and Palette is a large painting, the same height but wider than Portrait of Mme Matisse (fig.30); the goldfish bowl, although actually life-size, looms larger thanks to the close-up view. At this point Picasso's 'Synthetic' Cubist still lifes were not nearly as big, and when he saw the picture he might well have felt challenged. Matisse had not attempted to match Picasso's powerful, relief-like 'Synthetic' Cubist paintings (fig.26), or shown the least interest in making painted and constructed sculpture (fig.28), but he was demonstrating what could be achieved with a limited number of large, flat, strongly differentiated planes and that fussy decorative patterns derived from wallpaper and the like compromised grandeur and solemnity. Matisse had, in sum, revealed how well 'Synthetic' Cubism would adapt to a monumental scale, and when he saw Picasso's recently completed Harlequin (fig.36) in Léonce Rosenberg's gallery towards the end of November 1915 he was convinced he was face to face with Picasso's response to his achievement. In a letter to Picasso, Rosenberg described Matisse's reactions in detail: at first 'the Master of the Goldfish' was taken aback because Harlequin clearly marked a new departure; surprise rapidly yielded to admiration ('he honestly recognised that it was superior to anything you had done so far, and that it was the work he preferred to all others');

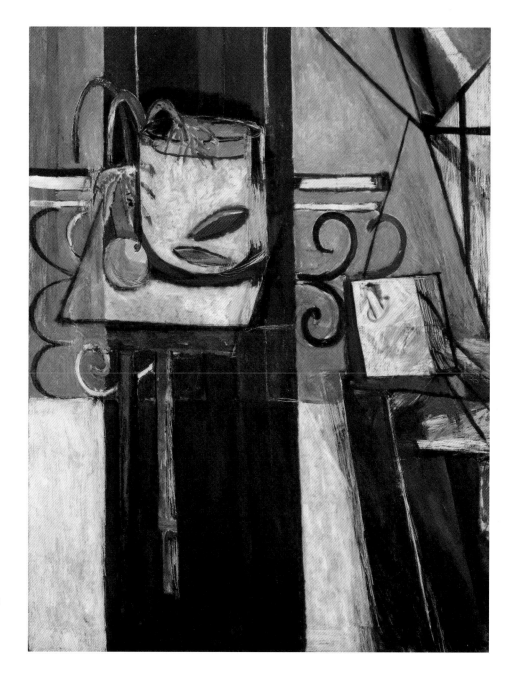

35
Matisse
Goldfish and Palette 1914
Oil on canvas 146.5 × 112.4 cm
The Museum of Modern Art,
New York. Gift and Bequest of
Florene M. Schoenborn and
Samuel A. Marx

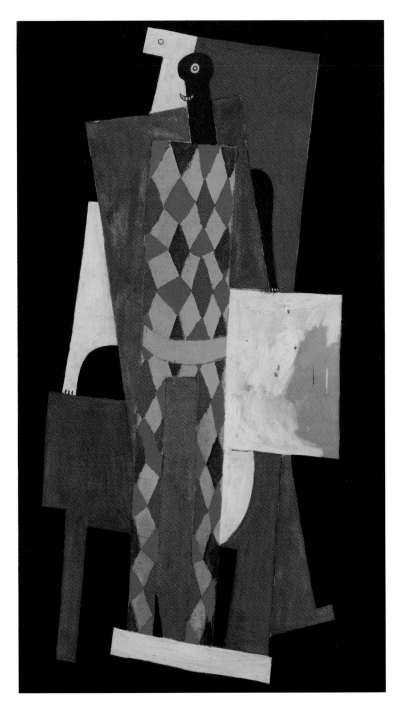

36
Picasso
Harlequin 1915
Oil on canvas 183.5 × 105.1 cm
The Museum of Modern Art,
New York. Acquired through
the Lillie P. Bliss Bequest

finally Matisse expressed the view that *Goldfish and Palette* 'may have led you to your *Harlequin*'.[46]

It was not, of course, as simple as that because *Harlequin* is directly related to *Violin* (1915, Musée Picasso, Paris), a large, boldly painted Cubist construction that Picasso made from cut and folded sheet-metal, and was probably the earlier of the two. But Matisse was surely right to think that the combination of flat black background, simple coloured planes and monumental scale in *Harlequin* owed something to his grandest and most abstracted paintings of 1914; he may also have believed that the enigmatic rectangular picture, imprinted with a ghostly profile and held up towards the spectator by the grinning harlequin, was derived from the vestigial palette in *Goldfish and Palette*. One would love to learn what Picasso thought of Matisse's claims. We know only that he was gratified by Matisse's praise, writing proudly to Gertrude Stein on 9 December 1915: 'I have done a *Harlequin* which in my opinion – and in the opinion of several others too – is the best yet.'[47]

The Matisse–Picasso exchange over Cubism was far from being exhausted by the end of 1915. Until Picasso went to Rome with the Ballets Russes company in February 1917 to complete his designs for the avant-garde ballet *Parade*, the two painters saw each other frequently in Paris. They were united in their anxiety about friends in the army. They were also united in their sense of isolation as non-combatants (in Picasso's case as a suspect foreigner); as revolutionaries currently under attack from conservative and chauvinist critics who accused them of fatally undermining French culture; as, moreover, artists who had been patronised by 'Boche' dealers and collectors. And they were united in their desire to make the most of the few opportunities to exhibit and to participate in cultural activities. It was during this period of frequent meetings that Matisse painted *The Piano Lesson* (fig.37), applying the structural principles of Cubist *papier collé* to a picture of dauntingly grand scale, which miraculously achieves a balance between austerity and richness, solemnity and liveliness, profundity and child-like simplicity. The painting depicts Matisse's youngest son Pierre practising to the beat of the metronome in the drawing room at Issy, but in a perceptive analysis of the imagery Jack Flam has argued that *The Piano Lesson* is a Matissean allegory about the nature of art and is as much a personal manifesto as 'Notes of a Painter'.[48] In being autobiographical in an indirect, coded manner *The Piano Lesson* has an underlying affinity with *Harlequin*, for *Harlequin* was painted while Picasso's lover, Eva Gouel, lay dying from cancer in a clinic, and depicts his favourite alter-ego as an outsize, disjointed cardboard puppet suspended against a funereal backdrop, perhaps the tragic toy of Fate, perhaps Fate's sinister emissary.

It was only after he had created his sets and costumes for *Parade* that Picasso sought to match more closely the huge scale of *The Piano Lesson* in a Cubist painting. *Three Musicians* (fig.38) was painted in Fontainebleau in the summer of 1921 and draws on his experience as a theatre designer not just for *Parade*, but also for subsequent commissions from Diaghilev for the *commedia dell'arte* ballet *Pulcinella* (1920) and then *Cuadro flamenco* (1921), a suite of Andalusian dances performed to traditional gypsy music and song. The fusion of the Italian *commedia* (Pulcinella and Harlequin) with the Spanish carnival (the Monk and the distinctively Spanish palette) in *Three Musicians* has therefore a specific context, and one could imagine the composition, greatly enlarged, serving as the drop-curtain for another ballet production. In its hectic fiesta-like ambience

37
Matisse
The Piano Lesson 1916
Oil on canvas 245.1 × 212.7 cm
The Museum of Modern Art,
New York. Mrs Simon
Guggenheim Fund

Three Musicians is totally unlike the becalmed, hushed *Piano Lesson*, and the kind of music-making that is going on is also totally different. Nevertheless, the ambition to make the language of 'Synthetic' Cubism so flexible that it could, when required, serve a decorative function, as the great naturalist styles of the past had done, owed more than a little to Matisse's example. Minor Cubist painters, who imitated his style dutifully, irritated Picasso and drove him to adopt radically different styles, so that by 1921 he was simultaneously producing figurative paintings in a full-blown neoclassical idiom antithetical to Cubism. But Matisse was the reverse of a dutiful follower, and his independent exploitation of Cubism led Picasso to invent *within* the style.

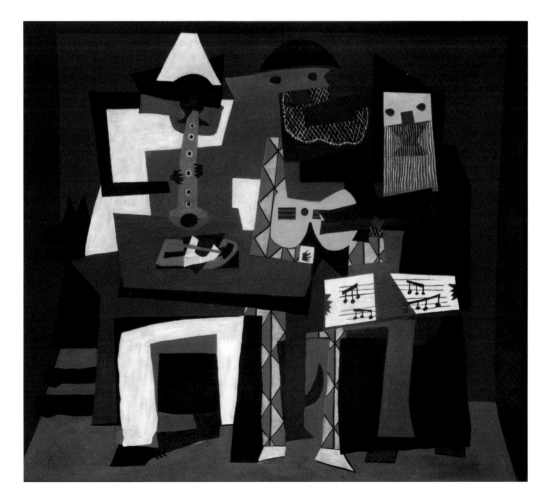

38
Picasso
Three Musicians 1921
Oil on canvas 200.7 × 222.9 cm
The Museum of Modern Art,
New York. Mrs Simon
Guggenheim Fund

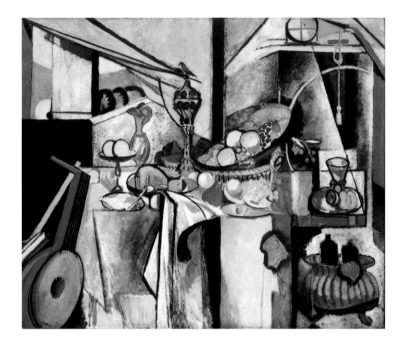

39
Matisse
Still Life after Jan Davidsz. de Heem's 'La Desserte' 1915
Oil on canvas 180.9 × 220.8 cm
The Museum of Modern Art,
New York. Gift and Bequest of
Florene M. Schoenborn and
Samuel A. Marx

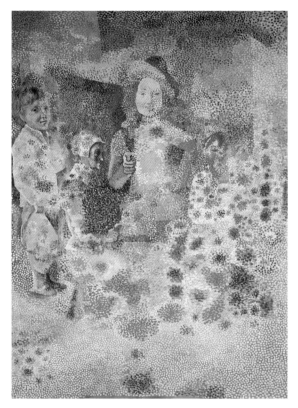

40
Picasso
The Return from the Christening, after Le Nain 1917
Oil on canvas 162 × 118 cm
Musée Picasso, Paris

Creative Copies

An intriguing aspect of the Matisse–Picasso dialogue is highlighted when their wartime 'copies' of seventeenth-century paintings are juxtaposed (figs.39, 40). In 1893, at the very beginning of his career, Matisse had made a faithful copy of De Heem's large and celebrated *La Desserte*, 1640, the first of a string of copies of old-master paintings in the Louvre. Copying the old masters was a normal part of an artist's training at the time and in the 1890s Picasso went through the same process. When Matisse set about making a new 'copy' of the De Heem in the summer of 1915 he worked from his 1893 canvas, not the original, and did so 'with the methods of modern construction', as he told Tériade.[49] By this he meant Cubism, and his desire to continue his exploration of the style with a cool head, critically and sceptically, emerges in the decision to set Cubism up in competition, as it were, with on one hand the Baroque illusionism of De Heem and on the other his own art of colour and decorative design. Matisse used the knowledge of Cubism gained in painting *Goldfish and Palette* (fig.35) the previous autumn, and there are passages in the De Heem 'copy' that remind one of passages in that painting – the awning, window view and flat black panel at the left side, in particular. Other passages, such as the mandolin, which is viewed from several points, recall early Cubist paintings by Braque, and the strongly marked grid orchestrating the dense groups of objects on the table is indebted

to paintings of 1912–13 by Gris. Picasso is also a background presence: the exploration of effects of stepped-forward projection, bending, folding and hollowness reflects Matisse's scrutiny of relief-like paintings such as *Table with Violin and Glasses* (fig.26).

Picasso's bizarre pointillist 'copy' of Louis Le Nain's *Return from the Christening* 1642 (now known as *The Happy Family*) is a more extreme case of the same phenomenon of copying used as a means of personal artistic development, rather than as a means of reproducing faithfully and paying homage to the source. Picasso was working from a photograph – Le Nain's painting did not enter the Louvre until 1939 – and whereas Matisse remained faithful to the basic composition of De Heem's still life, he made radical changes. For example, he switched the format from horizontal to vertical and eliminated the figure of the boy on the right. The most dramatic change, however, was his rejection of Le Nain's earthy palette and realist style in favour of the prismatic hues and confetti dots of Neo-Impressionism. Picasso's experiment with a greatly abstracted version of this passé, but once revolutionary style, which Matisse had used briefly in 1904–5, suggests that in 1917 he wanted to test its potential as a modernist alternative to Cubism. Translating the Le Nain into the appropriated foreign style was a way of assessing it against other styles he was using at the time, including Cubism,

rather as Matisse assessed the limitations and potential of Cubism in his version of De Heem's *La Desserte*.

Picasso's 'copy' was made in full knowledge of Matisse's 'copy'. We can be certain about this because Matisse sold his picture to Léonce Rosenberg in mid-November 1915, just when Rosenberg bought *Harlequin* (fig.36) from Picasso. Perhaps, therefore, it was a response to the Matisse. In any case, both 'copies' show that even when – perhaps particularly when – Matisse and Picasso were in consciously experimental mode they acted with one eye on the old-master tradition and were determined to remain in contact with that tradition. No contempt for the source itself was implied by the radical deviation from its style: Matisse continued to admire De Heem's painting and Picasso later bought two seventeenth-century pictures that at the time were firmly attributed to the Le Nain brothers. In their radical, exploratory transcriptions, the crippling academic discipline of copying 'with minute exactitude, according to the letter and not the spirit of the work'[50] was turned on its head, and the old masters were restored to their rightful position as an inexhaustible and vital source of inspiration and a springboard for personal invention.

Neither Matisse nor Picasso ever deviated from this position and ultimately it became one of the strongest bonds between them, effectively separating them from contemporaries (such as Piet Mondrian and Wassily Kandinsky) who embraced total abstraction and thus, on the surface at least, severed their ties with the old-master tradition. Matisse, for example, returned to Padua to study his beloved Giotto, and the free transcription of old-master paintings developed into a veritable genre in Picasso's repertoire. Indeed, from the late 1940s until the early 1960s making suites of variations after famous paintings became a principal occupation for Picasso. One painting he chose for this purpose in 1950, Courbet's *Women on the Banks of the Seine* of 1856, was a painting for which Matisse owned an important preliminary study, and, as we shall see, his series of free variations after Delacroix's *Women of Algiers* (fig.63), painted just after Matisse's death, involved a protracted dialogue with his departed friend.

Shared Themes

The Dance

The subject of the dance fascinated both Matisse and Picasso, inducing them to forgo their usual preference for static, contemplative themes. This interest was felt by many artists in the wake of the spectacular successes at the turn of the century of avant-garde dancers such as Loïe Fuller and Isadora Duncan, and from 1909 of Diaghilev's Ballets Russes. It was also fuelled by anthropological and ethnographical studies of the role of the dance in 'primitive' societies. The motif of a ring of naked female dancers took root in Matisse's art with *Le Bonheur de vivre* (fig.6). It came into its own, however, with the great mural painted for Shchukin in 1909–10, which was preceded by the equally large but more softly coloured and less dynamic sketch known as *Dance I* (1909, The Museum of Modern Art, New York). Remaining unsold in Issy, *Dance I* started to appear in Matisse's paintings of his studio, where it stood not just for itself, but for the very idea of making art. *Nasturtiums with 'Dance' II* of 1912 (fig.41) shows a narrow slice of the Issy studio and closes in on the left two-thirds of the mural (compressed and viewed at an oblique angle).

In the other paintings in which *Dance I* featured, Matisse respected its basic colour scheme, while adjusting its composition to the requirements of the new work. Here, however, he radically altered the colour of the sketch, heating up the pinks of the flesh, deepening the blue of the sky and obliterating the green of the grass under the same rich blue, so that the figures' dance appears dematerialised, airborne and visionary. This effect is enhanced by his repainting of the steeply raked studio floor a deeper shade of blue, so that it is virtually continuous with the mural, destabilising the spectator's reading of the depicted space. The same process of dematerialisation affects the dancers' bodies, which have visibly been pared down and are on the point of sloughing their female characteristics. The central figure of the fragment of *Dance I* now appears to hang helplessly from her rigid horizontal arms, as if crucified on an unseen cross; the diving, falling figure on the far right has shrunk to a boneless wraith, her stretched-out arm to a pathetic stick; only the dancer on the left seems unquestionably alive and active. Dance of life seems to be metamorphosing into dance of death, the empty chair in the foreground reinforcing the symbolism of loss. In utter contrast, the hanging tendrils of nasturtium burst from the glowing pot-bellied jar mounted on the sturdy sculptor's table, and dance exuberantly, throwing up their orange flowers, which open like three singing faces. This ambivalence in the imagery differentiates *Nasturtiums with 'Dance' II* from both the Arcadian innocence evoked in *Le Bonheur de vivre* and the Dionysiac revel depicted in the *Dance* mural itself.

41
Matisse
Nasturtiums with 'Dance' II
1912
Oil on canvas 190 × 114 cm
The Pushkin Museum, Moscow.
S.I. Shchukin Collection

42
Picasso
The Three Dancers 1925
Oil on canvas 215.3 × 142.2 cm
Tate. Purchased with a special
Grant-in-Aid and the Florence
Fox Bequest with assistance
from the Friends of the Tate
Gallery and the Contemporary
Art Society 1965

Picasso's fascination with the theme of the dance was linked closely to his experience as a designer for the ballet and to his marriage with Olga Koklova, a dancer in Diaghilev's company when he met her in Rome in 1917. Shortly before painting *The Three Dancers* in the spring-early summer of 1925 (fig.42), he had stayed in Monte Carlo with Olga and met up with their old Ballets Russes colleagues. While there he made scores of drawings of the dancers practising and resting. Among the sources for the composition of *Three Dancers* are old publicity photographs, and drawings that Picasso based on them in 1919–20, of Olga and two other ballerinas in *Les Sylphides*. In these Olga is the ballerina on the left, and looking at her fearsome and repellent counterpart in *The Three Dancers* it comes as no surprise to learn that in 1925 the marriage was already in a wretched state. The sense of impending cataclysm and excruciating neurotic tension, mirrored in the explosive rhythm, scissor-cut contours and dagger-sharp angles, is the crucial difference between *The Three Dancers* and Matisse's ultimately reassuring *Nasturtiums with 'Dance' II* with its engulfing and beautiful enamelled colours.

André Breton, the leader of the Surrealists, had bee a fervent admirer of Picasso's Cubist work since before the war. After the war a friendship between the two men developed, and from the official foundation of the movement in 1924 until the late 1930s Picasso can fairly be described as an ally and accomplice, although never a fully paid-up member. With brilliant perception, Breton linked *Les Demoiselles d'Avignon* (fig.12) with *The Three Dancers* in the issue of *La Révolution Surréaliste* for July 1925 in which the first installment of his essay 'Surrealism and Painting' was published. This culminates in an impassioned eulogy of Picasso.[51] In effect, Breton was claiming both pictures and their author for Surrealism, and art historians have drawn attention to the symmetry between *The Three Dancers* and Breton's concept of 'convulsive beauty' – beauty that captures, and induces in the spectator, feelings akin to hysteria, and which draws upon the transgressive depths of the human psyche disclosed through Freudian psychoanalysis. Indeed, the contorted, flailing dancer on the left of *TheThree Dancers* is like a cipher for a maenad in ecstasy or an hysteric in a seizure, while the molten forms of her torso reveal the impact on Picasso of the Surrealist cult of 'automatic' drawing. The rest of the painting is, however, broadly in the *papier collé*-derived style of *Harlequin* (fig.36) and *Three Musicians* (fig.38).

The personal relationship between Matisse and Picasso had been in suspension for some time when Picasso painted *The Three Dancers*. On 13 June 1926 Matisse noted in a letter to his daughter that he had not seen Picasso 'for years', and had not written to him either.[52] One factor in their estrangement was Matisse's decision to establish an alternative home and studio in Nice in December 1917. Another was probably Picasso's association with the Surrealists. Matisse was not sympathetic to the movement or its ideology of total revolution and was no doubt irritated by Breton's denunciations of the new, smaller, more naturalistic paintings he produced in Nice, which enjoyed considerable success with bourgeois collectors on both sides of the Atlantic.[53] But Breton's disgust was that of a disillusioned devotee, for he had been (and remained) enthralled by Matisse's pre-Nice work. One picture he particularly admired was *Nasturtiums with 'Dance' II*: a photograph of it was the sole decoration of his room in Nantes in 1915 when he worked as medical intern in a hospital.[54]

43
Picasso's studio at boulevard
Raspail, Paris, winter 1913, with
his first cardboard construction,
Guitar, and various *papiers
collés*. Photograph by Picasso.
Musée Picasso, Paris

One would like to know whether Breton saw any similarity between *Nasturtiums with 'Dance' II* and Picasso's *The Three Dancers*, and if the similarities were entirely fortuitous, or whether some memory of Matisse's painting lingered in Picasso's mind in 1925. The most immediately striking parallel is the way in which the hands of the dancers simultaneously touch and pull apart at the pivot of both compositions. More significant is the suggestion that both central dancers are crucified, that the one ecstatic figure is the dancer on the left, that the dancer on the right is a wraith, and that the dance is also a dance of death – suggestions that are far stronger in Picasso's violent and aggressively confrontational painting. In terms of the imagery, the salient difference is, of course, the absence in *The Three Dancers* of any equivalent to Matisse's life-affirming nasturtiums and of any reference to the painter's studio and thus to the business of making art. That allusion to art-making distances the spectator from the emotions and implications of the ritual of the dance; Picasso, by contrast, thrusts those emotions and implications in the spectator's face. This fundamental difference of approach is typical of the Matisse–Picasso axis.

The Artist and Model

The artist and model was another intrinsically meaningful subject to which Matisse and Picasso returned frequently, mindful of the great realistic and allegorical paintings on this subject from the past. Both had repeatedly drawn and painted from the posing model as students, but whereas Matisse maintained this practice throughout his career and was dependent upon hired models, Picasso virtually abandoned it after the turn of the century, reverting to it only occasionally when making portraits of individuals. When, therefore, Matisse depicted himself in the studio with a model, he represented what he actually did, day in day out; but when Picasso did so he appropriated familiar, generic iconography, just as he appropriated other familiar subjects (such as the crucifixion). Photographs of the artists in their studios draw attention to this crucial difference in working method. Matisse was photographed repeatedly working from his model, and the photographs were published in art journals at the time to make the point that his art was founded on the direct study of nature (fig.1). Picasso, by contrast, was photographed alone amid his work, with all the evidence of his astounding productivity strewn around him; or the studio itself, as his laboratory, was the subject of the photograph (figs.2, 43). The sheer orderliness of the depicted studio in Picasso's *Painter and Model* (fig.45) is proof of the generic nature of that painting, for Picasso's studio was never orderly and he rarely used a conventional palette or worked at an easel.

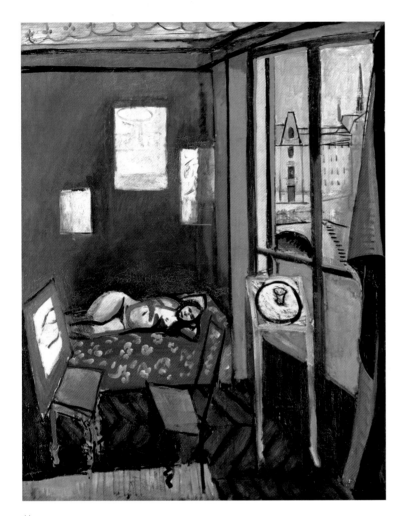

44
Matisse
The Studio, quai Saint-Michel
1916–17
Oil on canvas 147.9 × 116.8 cm
The Phillips Collection,
Washington DC

Matisse completed *The Studio, quai Saint-Michel* (fig.44) early in 1917 in his apartment-cum-studio overlooking the Seine. The Palais de Justice rises up forbiddingly between the window panes and seems to fix the beholder with four vertical eyes; beyond it one glimpses the spire of the Sainte Chapelle. In front of the window is the same small square table that supported the goldfish bowl and plant in 1914 (fig.35). So odd are the proportions and perspective that it looks as if it might have been painted by a child. The ornamental grillwork, which introduced a flamboyant note in *Goldfish and Palette*, has been effaced in the interests of the composition, but the zig-zags of the parquet are emphasised and a simple lacy pattern standing for the plaster moulding garlands the ceiling. Reclining on the bed is Matisse's current model, an Italian girl called Lorette (or Laurette; her surname is unknown). On this occasion, Matisse appears only by proxy in the form of his empty chair and the makeshift easel supporting his drawing board. The scenario implies that he has been drawing Lorette, close up, as was his wont, and that either he has stood up to survey the scene and perhaps to plan a painting of her, or that he is actually painting the scene we are gazing at, and hence is out of view. An intriguing ambiguity is thus insinuated. At all events, the existence of another painting the shape and size of a single bed confirms that Lorette did indeed pose in the nude on a bed draped in a red cloth and consequently that there is nothing fictional about either of the scenarios implied in *The Studio, quai Saint-Michel*. The abstracted style of *The Studio* demonstrates that being 'true to life' does not necessitate either illusionism or objective naturalism, and suggests that the painter's powers of inner vision and invention are liberated through the demanding discipline of looking intently at real things, provided always

that 'expression', not mere 'reproduction', is the goal. In Matisse's words it is the 'condensation of sensations' that 'makes a painting'.[55] As depictions of his own modest environment and as a testament to his dogged pursuit of 'expression' through study from life, *The Studio, quai St Michel* and Matisse's other contemporary studio paintings are revealing and moving. Yet they rigorously exclude any sign of human emotion, any trace of Romantic imagery denoting the turmoil of creativity, and strive instead for meditative calm. Despite being about Matisse's practice as a painter they have the dignified impersonality of the universal and timeless.

The Studio, quai Saint-Michel was included in the Matisse–Picasso show organised by Paul Guillaume in Paris in January–February 1918 – the first ever exhibition to link the two artists together. More

relaxed and naturalistic paintings on the theme of the artist and his model, which Matisse produced in Nice, were exhibited in his regular one-man shows at the Galerie Bernheim-Jeune in the post-war years. The motif thus became in a sense Matisse's property, and when Picasso addressed it in a sequence of large, highly conceptualised canvases in 1926–8 he challenged both the premises of Matisse's art and his territorial rights to the subject. In *Painter and Model* of early 1928 (fig.45) the reference to Matisse has a humorous, teasing edge, for while the set-up of the artist at work on his canvas before the posing model is the set-up Matisse depicted again and again, Picasso's painter and model are bizarre, dehumanised hieroglyphs utterly unlike their counterparts in any painting by Matisse, or indeed by anyone else who treated this subject. Several passages in *Painter and Model* imply a pointed dialogue with Matisse. The hieroglyph for the painter is composed from cryptic signs for the traditional artist's floppy beret (the grey and black interlocking half-circles either side of the staring face) and an easel (the tripod beneath the head), yet he is camped on an armchair covered in the kind of boldly patterned fabric Matisse had represented in canvas after canvas since the Fauve period. In the centre of Picasso's painting is a large window, a signature motif in Matisse's oeuvre and almost always a key player in his studio paintings, whether or not the artist himself appears. (See figs. 25 and 35, as well as *The Studio, quai Saint-Michel*.) In front of the window is a still life, a favourite combination in Matisse's studio views. And the method for evoking effects of space and light seems to parody Matissean devices, in particular his use of substantial areas of flat colour and of luminous pure black treated as if it were a colour.[56] Although Matisse was not the only artist Picasso had in mind

45
Picasso
Painter and Model 1928
Oil on canvas 129.8 × 163 cm
The Museum of Modern Art, New York. The Sidney and Harriet Janis Collection

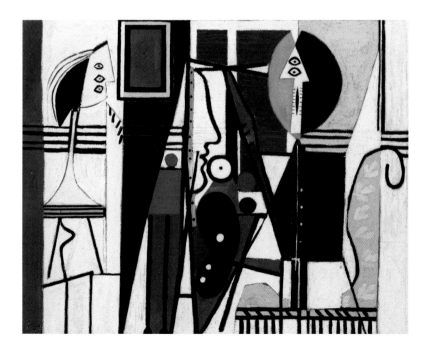

as he composed this grand quasi-Cubist picture, it was his insistence on the centrality of painting from life in the post-war period that seems to have been Picasso's main target. In *Painter and Model*, where the model and the picture on the canvas are at odds stylistically and nothing is depicted in a lifelike manner, Picasso indicated his commitment to a different principle, which he articulated in an interview given in 1923: 'Nature and art, being two different things, cannot be the same thing. Through art we express our conception of what nature is not.'[57]

Odalisques and Dreamers

Matisse emerged as France's latest painter of odalisques during the 1920s. Although he had his own memories of *'le proche orient'* to draw upon, his odalisque paintings were largely, and explicitly, artificial constructions created with the harem paintings of Ingres and Eugène Delacroix in mind. The model for most of them was Henriette Darricarrère, a talented young woman with a flair for acting, and the setting was Matisse's studio in Nice, which was equipped with a low stage, wooden frames to support the gaudy textiles he draped over them, various carpets, rugs and decorative pieces of furniture, and a mass of more or less exotic ornaments that were used as theatrical props. There was no pretence of authenticity within the paintings themselves, and contemporary photographs of Matisse in his studio (fig.1) drew attention to the make-believe nature of the decor. The odalisque paintings can thus be seen as an outgrowth of the still lifes that Matisse painted before the war, in which his figurative sculptures sometimes appeared, Galatea-like, to come alive.

Decorative Figure on an Ornamental Background (fig.47) aroused controversy when it was exhibited at the Salon des Tuileries in June 1926, some critics praising Matisse's daring in forcing a marriage between the rigid, geometricised nude with her wooden-doll head and the flamboyantly decorative background, others deploring this resurgence of the intransigent Fauve spirit. This nude was no one's idea of the lovely, sensual, available odalisque (compare fig.14) and the painting seemed to flout convention, as *Blue Nude* (fig.13) had done years before. Picasso must have been aware of the fuss, just as he must have been aware of the allusion to Delacroix's *Women of Algiers* (fig.46) in the pose of the figure, the arrangement of carpets on the stage and the tell-tale ornamental mirror. He would have appreciated the imaginative, personal interpretation of the Delacroix because alluding to other works of art was something he did constantly himself. His staggeringly grotesque *Large Nude in a Red Armchair* of 1929 (fig.49) is a travesty of the harem genre and of Matisse's perpetuation of it in the earlier, more seductive and more naturalistic odalisque paintings painted in Nice. And, of course, in being

46
Eugène Delacroix
Women of Algiers 1834
Oil on canvas 180 × 290 cm
Musée du Louvre, Paris

47
Matisse
**Decorative Figure on an
Ornamental Background**
1925–6
Oil on canvas 130 × 98 cm
Centre Georges Pompidou,
Paris, Musée National d'Art
Moderne/Centre de Création
Industrielle. Achat à l'artiste
en 1938. Fonds national d'art
contemporain

48
Matisse
Large Seated Nude 1925–9
Bronze 79.4 × 77.5 × 34.9 cm
The Museum of Modern Art,
New York. Gift of Mr and Mrs
Walter Hochschild (by exchange)

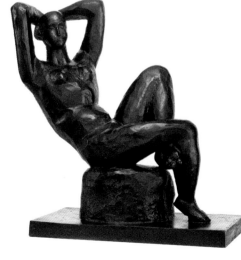

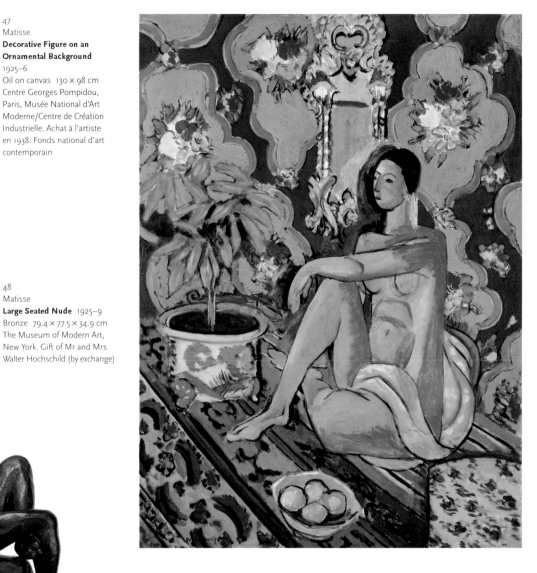

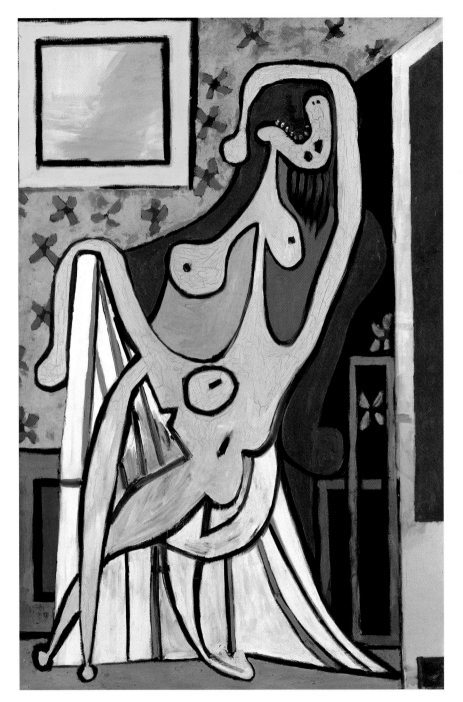

49
Picasso
Large Nude in a Red Armchair 1929
Oil on canvas 195 × 130 cm
Musée Picasso, Paris

50
Picasso
Seated Woman 1929
Bronze 42 × 16.5 × 25 cm
Musée Picasso, Paris

flatly painted in a decorative manner and in aping Matisse's beloved serpentine line, it grossly caricatures the style normally identified with him.

Like *The Three Dancers* (fig.42), which travesties the familiar motif of the Three Graces, *Large Nude in a Red Armchair* is so outrageous partly because it has a classical, centralised structure, and therefore seems to be not just a parody of, but a violent attack upon the classical tradition as such. The female body, usually synonymous with beauty and life, has been transformed into a hideous, boneless, tentacular monster resembling a punctured, shrivelling balloon; pleasure-giving colour and pattern are mocked in the absurd flowers spattering the wallpaper and in the caked, cracked surface of the painting itself. Like *The Three Dancers*, the figure is 'convulsive' in the Surrealist sense and explores the 'forbidden zone' of sexuality that was Surrealism's preferred domain. The imaginative excesses of paintings such as *Large Nude in a Red Armchair* delighted Picasso's supporters in both Breton's camp and in the camp of the dissident Surrealists gathered around that implacable enemy of the ideal, Georges Bataille, but they appalled mainstream critics when they were exhibited during the 1930s. Claude Roger-Marx felt that Picasso's 'evil inventions' created an 'atmosphere of crime';[58] Louis Gillet, of the Académie française, denounced his 'sad caricatures, insane in their outrageousness, which deride and insult the human form', and called Picasso himself a 'monster of egotism, pride and impersonality'.[59] But the nihilism of such paintings was only half the story at any moment in Picasso's work: the Janus-face of *Large Nude in a Red Armchair* is *The Dream* (fig.54), which takes the same subject but suggests replete, joyous sensuality instead of loathing and disgust.

Throughout their careers Matisse and Picasso were linked in their ambition to be painter-sculptors in the tradition of masters of the past such as Michelangelo, and Edgar Degas in the modern era. While it is true that their sculpture often sprang from their painting and was sometimes made as an aid to its development, it was never merely a subsidiary activity: the relationship between the two media was symbiotic and sometimes their sculpture was more adventurous than their contemporary painting. Arguably, this was so in the case of Picasso's Cubist constructions (see figs.28, 43), which literally revolutionised the practice of modern sculpture. *La Serpentine* (fig.51), completed in the autumn of 1909, and first exhibited in 1912–13, is one of Matisse's most daring inventions, and like many of his sculptures it began as a more naturalistic study of the figure, although in this case the model was a photograph of a (very plump) nude woman. As work on it progressed, it became more primitive in style, the torso and arms coming to resemble those snakes of pliant clay formed simply by rolling them in the palms of the hand and which can be twisted into shape as easily as wire. In parallel, the negative spaces between the limbs and torso, and the figure and its supporting plinth, grew in size, assuming the significance of the negative spaces in Matisse's contemporary paintings. Yet the classic *contrapposto* pose was retained and, like the gross, ungainly plinth, alludes with more than a touch of irony to canonical antique statues.

Picasso must have been fascinated by *La Serpentine* for it seems to have influenced the conception and execution of several of his sculptures. *Seated Woman* (fig.50) is the exactly contemporary, sculpted counterpart of *Large Nude in a Red Armchair*, and typically Picasso went that bit further than Matisse, for it is rougher and cruder in execution than *La Serpentine* and was

actually assembled from separately rolled and modelled sections, which were then fixed together and propped against the massive chair, the left arm acting as a cord to keep the legs in place. Negative space plays only a very minor role in this sculpture, but it plays a major role in the larger *Reclining Bather* of 1931 (fig.52), where the low plinth acts as the support to the interlocking and twisting forms stretched out upon it. In the interim, Picasso had had the chance to study *La Serpentine* again in detail, for it was included in Matisse's exhibition of sculpture at the Galerie Pierre in June-July 1930,[60] and to observe the sinuous unfolding of its contours as he moved around it. Metaphor and the idea of metamorphosis are, in Surrealist fashion, crucial to both sculptures by Picasso: the seated woman resembles a bundle of sticks, bones and dried out roots, all dead things, whereas the bather recalls living and growing tubers and roots. *La Serpentine* implies organic growth in its swelling, stretching forms, but true to the empirical foundations of his art Matisse stopped short of creating a hybrid, unclassifiable species.

51
Matisse
La Serpentine 1909
Bronze 56.5 × 28 × 19 cm
The Museum of Modern Art,
New York. Gift of Abby Aldrich
Rockefeller

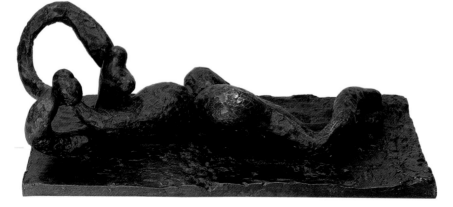

52
Picasso
Reclining Bather 1931
Bronze 23 × 72 × 31 cm
Musée Picasso, Paris

Large Seated Nude (fig.48) was not completed until 1929 but Matisse began work on the sculpture in 1925 in tandem with his preparatory work on *Decorative Figure on an Ornamental Background*. Photographs taken in his studio in Nice show that it was at first less abstracted and muscular, with full, rounded, smooth surfaces and streamlined contours. Dissatisfied with the relatively conventional style of the sculpture in its early state, Matisse infused it with tension and drama by using a knife to accentuate the angles of the bent arms, to slice off the fullness of the hips and thighs, and to cut into the waist and facet the torso. In so doing he reverted to the more experimental style of earlier sculptures that reveal his response to 'Analytical' Cubism, such as *Back III* of 1916. In its final athletic incarnation, *Large Seated Nude* is noticeably closer to Michelangelo's sculptures of *Dawn* and *Night* 1524–34, which Matisse had drawn intensively from the casts in the Ecole des Arts Décoratifs in Nice, hoping, as he wrote in a letter to Camoin of 10 April 1918, 'to instill in myself the clear and complex conception of Michelangelo's construction'.[61] The studio photographs also establish that the nude in *Decorative Figure*, which at one stage was relatively naturalistic, acquired her blocky masculine traits before Matisse made the radical alterations to *Large Seated Nude*. Ultimately, however, he pushed the sculpture further, so that in its definitive form it is tougher, harsher and tenser than the painted figure. It is quite often the case that Matisse's sculpture is more provocative and disquieting than the related paintings, which is one reason why it interested Picasso so much.

The final painting for which Henriette Darricarrère posed is *Woman with a Veil* of 1927 (fig.53), an intense study in which, for once, she looks directly and intently back at Matisse, albeit

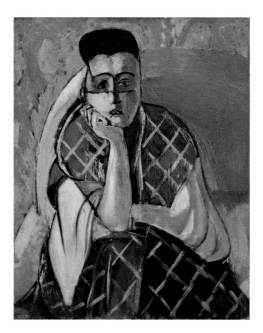

through the filter of fine black net. Her costume is a strange confection, perhaps consisting of a white peignoir and a length of boldly chequered fabric draped to form a voluminous cloak. Together with her veil and the patterned screen, which appears in several other paintings for which Henriette posed, it suggests the 'orient', but only vaguely, as if Matisse wished to acknowledge the centrality of dressing-up in all the paintings for which she modelled (even those in which she wears contemporary fashions). Also unusually, the face is not a generalised mask – less of a mask than the face of Madame Matisse in her portrait of 1913 (fig.30), less generalised than the averted face of Greta Prozor (fig.33). A sense of the strength of Henriette's personality and of the collaborative rapport between model and painter comes across. Matisse had depicted Henriette in this pose, head in hand, leaning

on a table and facing him, in *The Pink Blouse* of 1923 (The Museum of Modern Art, New York), but there her head was inclined to her right, implying pensive daydreams. In *Woman with a Veil* Henriette thrusts forward, demandingly, the fixity of her expression underlined by the horizontal of the veil and the vertical line running through the cleft in her brow, and down her nose, her solid, column-like arm and her jutting knee, which is marked out by the dramatic change in colour of the skirt from red to black. In being a forceful, sculptural presence she could be described as typically Picassoesque: one thinks of *Portrait of Gertrude Stein* (fig.4). And it is tempting to associate her parti-coloured costume and eye-mask with Picasso's alter-ego, Harlequin (see fig.36), and thus with the Cubist painting we know Matisse greatly admired.

In June–July 1931 Matisse was the subject of an immense retrospective exhibition at the Galeries Georges Petit. Several of his odalisque paintings were included and in general the exhibition focused on his post-war work. Eye-witnesses report that Picasso attended the *vernissage* and 'was much in evidence', more so than Matisse himself who 'slipped away early in the evening, preferring that his pictures speak for him'.[62] The *vernissage* may mark the resumption of personal contact between the two artists. In any case, various documents establish that they saw each other with increasing frequency and cordiality in the mid and late 1930s, despite the fact that the majority of critics persisted in describing them as locked in obdurate rivalry.[63]

Their convergence during the 1930s is not surprising. Quite apart from the fact that their sheer fame thrust them together, it must have been crystal clear to both that whatever the critics might say, they had more in common with each other than with any other artist (even including former painting partners such as Derain and Braque). Thus although Picasso had been closely involved with the Surrealists since the foundation of the movement in 1924, whereas Matisse had steered clear, he had never practiced 'pure psychic automa-tism' (except now and then experimentally) and never become a painter of Freudian narratives derived from dreams. At a time when total abstraction of various types looked as if it might become the dominant avant-garde mode for non-Surrealists, both artists were united in rejecting pure abstraction and remained committed to depicting the material world and to working in the traditional genres used by their favourite artists of the past. There were differences in subject matter, of course, but the majority of their works fall within a very limited repertory, mostly involving the seated or reclining female figure. Although they thought of themselves as painters, both, as we have seen, devoted con-siderable time and effort to sculpture. Both were extremely prolific draftsmen, using drawing in all the ways they had been taught to use it when students. Similarly, both were committed to print-making and produced a significant body of illustrated, limited-edition *livres d'artistes*. Both, in short, had the ambition to be 'complete' artists in the traditional sense. Most significant of all, in the sometimes iconoclastic, often profoundly troubled interwar period, neither came to the conclusion that the primary function of art is to serve a social or political cause, just as neither was ever in the slightest doubt that making art 'for its own sake' is a supremely worthwhile activity.

The Dream, dated 24 January 1932 (fig.54), was exhibited in Picasso's vast retrospective held at the Galeries Georges Petit exactly one year after Matisse's retrospective there. Many reviewers were offended by the astounding stylistic variety of the

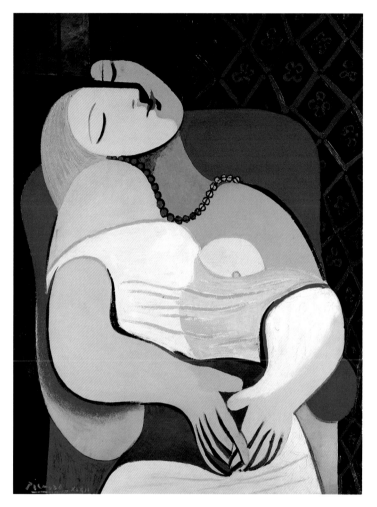

54
Picasso
The Dream 1932
Oil on canvas 130 × 97 cm
The Wynn Collection,
Las Vegas, Nevada

works of all periods on display and some did not hesitate to call Picasso capricious and demonic. Furthermore, the sheer acreage of barely dry canvas seemed proof of mindless mass-production, for twenty-one paintings executed between December 1931 and April 1932 were included, all but two as large or significantly larger than *The Dream*. Louis Mouilleseaux lamented the 'monumental vulgarity' of Picasso's 'latest manner' and his 'fabrication of very poor sub-Matisses, very poor fake Diego Riveras'. 'A whole room at Petit's, the largest, is papered with these errors', he wrote.[64] Other critics were equally offended by the signs of Matisse's influence, which undermined the cherished consensus view that the artists were always poles apart. Like other paintings in Picasso's series of voluptuous women, *The Dream* bears witness to his study of the Nice odalisques and to his resolve to match the splendour of Matisse's colour and his command of the all-over decorative surface. But to critics like Mouilleseaux, the bold stylisations, the grotesquerie of some of the paintings and their frank eroticism amounted to crude caricature.

In fact, this astounding creative spurt during the winter immediately following Matisse's retrospective in 1931 took place when Matisse himself was not painting any easel pictures, but concentrating on his commission for murals on the theme of the dance for the Barnes Foundation in Merion, near Philadelphia. No doubt there was an element of competitive bravado, for Picasso not only needed to match the achievement summed up in Matisse's retrospective, he had to make up for the fact that he was not painting murals, by common consent the most demanding enterprise for any painter.

Although much more naturalistic than *Large Nude in a Red Armchair* (fig.49) and *Reclining Bather* (fig.52), *The Dream* is nevertheless a symbolic

painting about erotic love rather than a straight portrait of the woman who inspired it, Picasso's young blond-haired mistress, Marie-Thérèse Walter.[65] In this sense Marie-Thérèse served as a vehicle to express a theme in much the same manner as Henriette Darricarrère served to embody Matisse's concept of the odalisque. Like a true emblem, the heart-shaped face of Picasso's dreamer contains both a pure profile and an almost full-face view, and the two join at the lips in a bright red kiss, suggesting that the girl's satisfied desire brings with it serene love of the self. The heart-shape is repeated in her torso, the line of the necklace tracing the dip at the top, the hands (loosely clasped over the pubic area) the tip at the base. The lover/painter's desire is symbolised in the phallic form of neck and head and in the incline backwards of the supine body away from the beholder: the story of Sleeping Beauty waiting to be kissed into life was surely in Picasso's mind, and the girl's air of perfect innocence is conveyed through the charm of the pastel hues used to describe her body and the naivety of the flower-patterned curtain to the right. The cascade of yellow hair may be a discreet allusion to the mythological story of Danae and Zeus's shower of gold; the glowing armchair creates a protective ring of fire. With these meaningful signs a banal domestic scene is transformed into the stuff of fairy-tale and myth.

Sublimation through poetic allusion and symbolism was central to the majority of the works in all media inspired by Marie-Thérèse Walter. The most extreme example of this is the towering *Large Still Life on a Pedestal Table*, which Picasso painted in March 1931 in the prismatic colours he particularly associated with her (fig.61). Nearly forty years later he confirmed Pierre Daix's hunch that within its curvilinear design lay hidden the outlines of

Marie-Thérèse's body.[66] The symbols of vase, fruit, forms like sprouting seeds or plants, sunshine and springtime growth, which are used to conjure up the buried image of a beautiful, fertile young woman, are traditional ones, so Picasso's 'surrealism' had a familiar foundation and his secret code is not difficult to crack. Matisse did not use codes in this way: although he frequently associated beautiful young women with vases of flowers, bowls of fruit and streaming sunshine, in his paintings these things do not stand in for or become a woman. Another key difference between the two artists is that whereas Picasso's work, especially during the 1920s and 1930s, tended to veer dramatically between the celebratory (*Large Still Life on a Pedestal Table*) and the hag-ridden (*Large Nude in a Red Armchair*), the tender (*The Dream*) and the convulsive (*The Three Dancers*), Matisse avoided such violent pendulum-swings.

Matisse returned to easel painting in 1934. Early the following year Lydia Delectorskaya, who had been a studio assistant when he was working on the Barnes murals, began to pose for him, the start of a relationship that led eventually to the breakdown of his marriage and endured until his death. *Large Reclining Nude*, better known as *The Pink Nude* (fig.55), was completed after some seven months of work at the end of October 1935. By then it had been through more than twenty states, documented in photographs that chart its bumpy progress from recognisable, if schematic, representations of Lydia's face and body, the couch and the corner of the room housing the scroll-backed chair and vase of flowers, to the extreme simplicity and abstraction of the final state.[67] The difference from the portrait-like, sculptural *Woman with a Veil* of 1927 (fig.53) is striking, and several writers have suggested that in reverting to the style of his most radical pre-Nice

works Matisse was propelled by the spectacle of Picasso's bold interpretation of the 'signature' Matissean style in *The Dream* and the other Marie-Thérèse paintings.[68] Contemporary critics detected the influence of Picasso when Matisse showed a group of recent paintings (including *The Pink Nude*) in the Galerie Paul Rosenberg in May 1936, just two months after an exhibition of Picasso's work in the same gallery. Claude Roger-Marx was horrified, seeing nothing but 'vanity' in this effort to catch up with the 'innovators' through a display of spurious 'adventurousness': 'Is the Rosenberg gallery impregnated with the latest Picassos? It is he who comes to mind at the very first glance', he wrote. 'This is a new kind of criminal assault: the assault of an artist against himself . . . One can tolerate in Picasso, a typically Spanish painter, an approach which one has trouble accepting in a French artist . . . Matisse is doing violence to his true nature.'[69] This is another instance of the censorious reaction whenever either of the artists left what was considered to be his proper sphere.

Comparison between *The Dream* and *The Pink Nude* reveals characteristic differences as well as

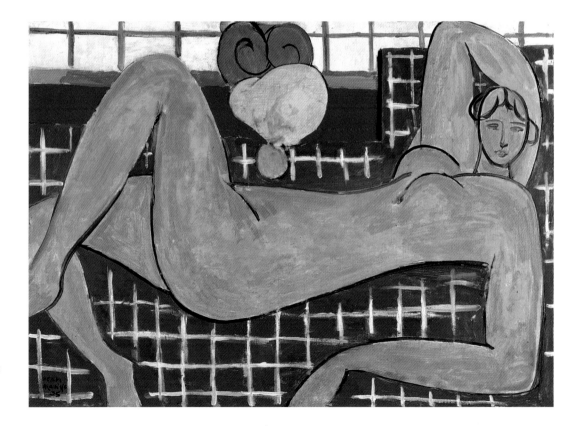

55
Matisse
**Large Reclining Nude
(The Pink Nude)** 1935
Oil on canvas 66 × 92.7 cm
The Baltimore Museum of Art:
The Cone Collection, formed
by Dr Claribel Cone and
Miss Etta Cone

similarities. *The Dream* emerges as more classical in its centralised and contained composition and in its treatment of space, for although Picasso used devices to unify the surface as a decorative entity by tying the figure to the background (for example, the horizontal of the chair-rail is continuous with the contour of the nose), he described recession in such details as the overlapping fingers and in the gradual movement from the bottom edge of the canvas, which cuts the thighs, up the meandering central line of the body, to the darker, more shadowy background. Three-dimensionality is invoked in the shading under the left arm and beneath the head and in the ruckled drapery. In *The Pink Nude*, by contrast, Matisse treats the deep pink body, patterned couch, still life and wall as flat surfaces, duplicating and echoing the flat rectangle of the canvas. Breaking with classical conventions, he not only suggests the continuation of the square grid

beyond all four edges of the frame but crops the right knee, both feet and the left hand. Lydia thus becomes the predominant element in a spreading, all-over surface design. There are, it is true, indicators of three-dimensional mass and space: the overlapping legs, the rising mounds of the breasts, the pale cyclamen line denoting the top of the crimson shelf, the dark halo breaking the blue and white grid around the contours of the body, and so on. But a comparison between, say, the faces of the two models reveals how much more abbreviated *The Pink Nude* is than *The Dream*. Both artists were clearly inspired by Ingres in these pictures (as in so many others). Significantly, however, Matisse was responding to his highly abstracted odalisques, which had shocked his contemporaries through their wilful disregard of anatomy and three-dimensionality (fig.14), Picasso to the more realistic portraits.

The War Years

As the political situation worsened Matisse and Picasso drew closer, united in their loathing of Fascism. At the outbreak of the Spanish Civil War, Picasso was named titular Director of the Prado and became involved in schemes to raise money for the Republican cause and for Spanish refugees. Like Picasso, Matisse signed telegrams of support sent to the Republican government and donated pictures to various relief funds. Both watched in despair as the Nazis despoiled the German museums of 'degenerate art' (their pictures included), and both were involved in major group exhibitions organised at the time of the International Exhibition in Paris in 1937, where the excruciating tensions of the moment were embodied in the rival pavilions of Nazi Germany, Fascist Italy, the Spanish Republic and the Soviet Union. Matisse took a particular interest in the progress of *Guernica* (1937, Centro de Arte Reina Sofia, Madrid), which was commissioned for the Spanish pavilion, visiting Picasso in his studio before it was completed and then going to see it when it went on display. Appropriately, it was at this time of increasing intimacy that the second ever Matisse–Picasso exhibition was held at the Boston Museum of Modern Art, in October–November 1938, a prelude to the more important and controversial third such exhibition, which opened at the Victoria and Albert Museum in London in December 1945. Underlining their rapport, in the spring of 1939 Picasso bought an early, vividly colourful flower painting by Matisse from Ambroise Vollard,[70] to the delight of Matisse when he heard about it. The new acquisition accompanied Picasso when he fled Paris for Royan at the outbreak of war that September; it can be glimpsed in photographs of the makeshift studio he set up there.

In their art, however, a gap opened up. The two still lifes of 1941 discussed earlier (figs.21, 22) give an idea of the different manner in which Matisse and Picasso reacted to the catastrophe engulfing Europe and to their different circumstances. A comparison between two large figure paintings on the theme of the serenade reinforces the impression of divergence, following the convergence of the 1930s, a divergence that was already apparent in *Guernica*, with its searing imagery of protest, pain and slaughter, its black, white and grey palette and its expressionistic adaptation of Cubist geometry.

Matisse painted *Music* (fig.56) over a three-week period in March–April 1939. It was not a commissioned painting, but is related to decorations created for American clients that came his way as a result of the success of the Barnes murals. As usual it went through numerous states before Matisse was satisfied. He told Lydia Delectorskaya that it was only after he changed the direction of the legs of the figure on the left that he was able to complete it. (At first her legs were angled to the spectator's right, and later vertically, before he decided to swing them

to the left.)[71] As usual, then, the problems were pictorial, exacerbated no doubt by the choice of a perfectly square format that on one hand entailed the danger of creating too trite and regular a surface pattern, and on the other jeopardised the balance between the figures and their environment, which is achieved more naturally in the familiar landscape and portrait formats. (Matisse had used the square format before, but not often.) The attractive subject laid another trap – too facile an opposition between the women and too facile an equation between musical and pictorial rhythm. The numerous devices Matisse introduced to avoid these pitfalls, while still exploiting the decorative potential of the square, are dazzling in their inventiveness, and as he often had in the past, he not only introduced disruptive asymmetry but discordant accents of 'ugliness', crudeness and harshness to create tension and surprise into what might otherwise have been a purely diverting scene. The grotesque foot and lumpish hand of the guitarist, the child-ishly simple formula for the other woman's features, the brash complementary contrast of red and green, the method of scratching and scoring into the wet paint instead of drawing, fulfil this disruptive function.

The emotional gulf between *Music* and *Serenade* (fig.57) is so great that one might think their authors came from different planets. Yet Picasso's numerous preparatory drawings for his huge canvas reveal that his original idea was for a scenario that crops up in several of Matisse's odalisque paintings of the 1920s: two comely nude figures, one sprawling on a striped couch with her arms raised seductively above her head, the other seated. The drawings are dated September 1941; the painting itself was completed in May 1942. In the interim Picasso had decided against the Matissean

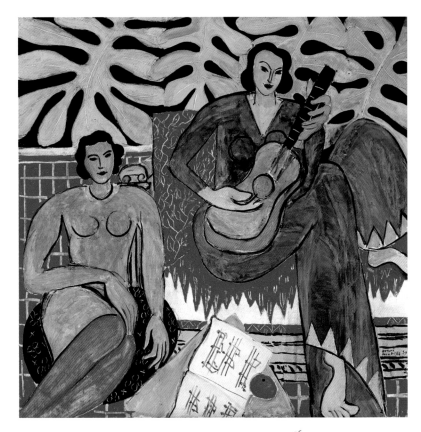

56
Matisse
Music 1939
Oil on canvas 115 × 115 cm
Albright-Knox Art Gallery
Buffalo, New York. Room of
Contemporary Art Fund, 1940

57
Picasso
Serenade 1942
Oil on canvas 195 × 265 cm
Centre Georges Pompidou,
Paris. Musée National d'Art
Moderne/Centre de Création
Industrielle. Don de l'artiste
en 1947

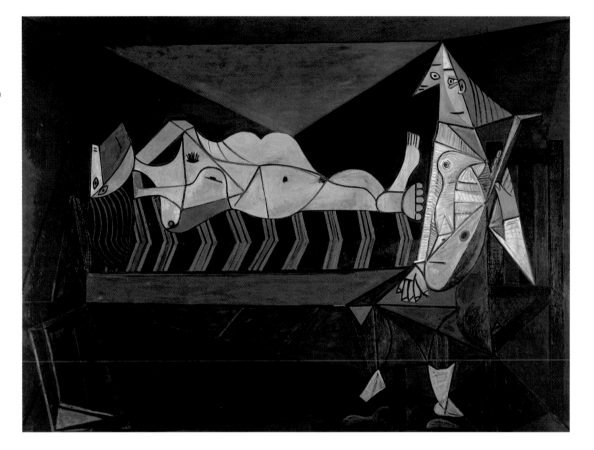

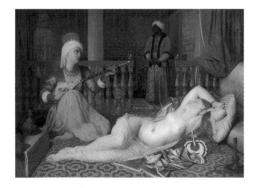

58
Jean-Auguste-Dominique Ingres
Odalisque with Slave 1839–40
Oil on canvas mounted on
panel 74.9 × 102.9 cm
Courtesy of the Fogg Museum,
Harvard University Art
Museums, Cambridge. Bequest
of Grenville L. Winthrop I

option in either composition or style. However, he undoubtedly continued to think in terms of the odalisque genre because the composition of *Serenade* alludes to Ingres's celebrated *Odalisque with Slave* of 1839–40 (fig.58). In the Ingres, the slave girl serenading the alluring naked odalisque is on the left. By reversing the orientation of the composition, Picasso signalled the bitter irony of such fantasies of 'oriental' pleasure in Occupation Paris. In his painting the enclosed, but luxurious and pampered world of the harem has turned into a narrow, windowless prison from which no escape seems possible, and the exotically attired and beautiful slave has transmuted into a grotesque concierge-cum-duenna in headscarf, socks and slippers, bundled into a thick sweater against the perishing cold of a city without fuel. Such a person would never play love music on a lute, and indeed the concierge holds the instrument gingerly with a bemused grin, as if aware of the folly of the painter expecting her to pose like this. Picasso's most terrifying and pathetic creation is the naked woman, trussed like a plucked chicken ready for the oven, her body mangled as if she has been wrung out like a rag, stretched on the bed like a martyr on the rack, an uncanny foresight of the horrific tortures and maimings that would come to light after the Liberation. Cubist geometry, faceting and multi-viewpoint have been brilliantly adapted to communicate claustrophobia and torture in a painfully visceral way.

Paintings such as *Serenade* provoked outrage when they were first exhibited, despite the fact that *Guernica*, which anticipates their style, had by then been hailed by many critics as the most moving statement of man's inhumanity to man of the modern era. Picasso's retrospective in Paris in the 'Liberation Salon' in October–November 1944 caused such violent demonstrations of anger that young artists mounted a guard to protect the pictures against assault. In London in December 1945, where *Serenade* was again exhibited, the storms of protest against 'Picasso's habit of shattering humanity to bits'[72] led to valiant attempts by admirers, including his future biographer Roland Penrose, to explain and defend his work on the radio and in the press. Such was the scandal over Picasso's paintings that Matisse's radiant and life-affirming pictures on show in the same exhibition barely raised an eyebrow. According to Eric Newton, 'Poor Matisse has almost been ignored or treated as no more than a chocolate-box painter.'[73] Matisse was well aware of this, remarking ruefully to Brassaï as he showed him the fat wad of English reviews: 'It's Picasso, not I, who received the majority of insults. They humour me. Beside him, of course, I always look like a gentle little girl.'[74] Jane Bussy, daughter of Matisse's lifelong painter-friend Simon Bussy, repeats a Matissean witticism in her astringent memoir: 'One day, entering La Coupole restaurant in Montparnasse and seeing a thrill go through the whole place and all the waiters bounding towards him – "*On me prend pour Picasso* [They take me for Picasso]", he murmured.'[75] This probably dates from just before the outbreak of the war and neatly summarises the transfer of power that had occurred. In the letters Matisse wrote to his son Pierre during the 1940s the metaphor of a boxing-match recurs when there is talk of the popular perception regarding his relationship with Picasso.

Peacetime Reunion: Before and After Matisse's Death

During the war, that relationship became noticeably more affectionate, despite their separation. Both were perfectly aware of the fundamental differences of vision but had the highest regard for each other's achievement. Hence the presence of *Still Life with Basket of Oranges* (fig.20) in the Liberation Salon of 1944, loaned by Picasso; hence the new spate of exchanges of pictures during the war. After the war, the friendship blossomed; meetings became fairly common whenever Picasso was in the south of France, as was increasingly the case from 1946 onwards. The flavour of their meetings is captured in the memoirs of Françoise Gilot, Picasso's new companion.[76] She was a fervent admirer of Matisse's work and this, in combination with her seductive youth and beauty, made Picasso's visits a most welcome diversion for Matisse, who complained whenever their tempo slackened. There were further exchanges of presents, occasional loans of works that could not be permanent gifts, and much examination of what the other was currently doing. In 1948 (when he was deeply involved in his designs for the Vence Chapel) Matisse went twice to the Palais Grimaldi at Antibes to see the decorations Picasso had painted for it, making detailed sketches the second time.[77] Picasso was censorious when he discovered that Matisse had agreed to design the decorations for the chapel at Vence: he thought it immoral for an agnostic to be working for the Catholic church.

But his reservations did not extend to the designs themselves and he did everything in his power to help Matisse obtain suitable ceramic tiles on which to paint his highly simplified murals.[78] He also visited the completed chapel on several occasions. Picasso's sense of the challenge represented by the Vence chapel emerges in his own *War* and *Peace* murals painted for a deconsecrated chapel in Vallauris in 1952, and in referring to Matisse's earlier 'pagan' work they reminded him of his 'error'. The zest of rivalry and disagreement was, in short, never entirely absent.

The rivalry and friendly chaffing between the two artists come out in the amusing caricatures that Picasso made in December 1953–January 1954 of a hunched, myopic, elderly Matisse lookalike peering over his glasses while drawing a lovely and aloof young model. In one drawing the model is so like Lydia Delectorskaya, as she appears in photographs taken in Matisse's studio in the late 1930s, that a reference to that particular relationship seems intentional. The absurdity of drawing a nude woman instead of making love to her, and of an impotent old man having access to a beautiful girl, is the satirical point of the series, and there is wry self-ridicule too, for when he made the suite of drawings Picasso had just been abandoned by Françoise Gilot and, now in his seventies, was uncomfortably aware of fast-approaching old age.[79] Underlying these drawings, of course, is also the

perennial debate between the two artists about the merits, or not, of working from life.

In 1946 Matisse embarked on the series of views depicting the interior of his villa Le Rêve at Vence, his sublime swansong as a painter. On his regular visits with Gilot, Picasso observed the progress of these pictures. He would, for example, have seen the sizzling *Red Interior: Still Life on a Blue Table* when it was brand new in 1947 (fig.59) and perhaps been reminded of Matisse's much earlier paintings where the surface is similarly inundated with intense colour that seems to spread beyond the frame (*The Red Studio* of 1911, for instance; fig.24). Matisse was being as audacious as in his heyday and was more uninhibited, as the relaxed technique suggests. It must have been at about this time that Picasso bemoaned what he felt to be his limitations

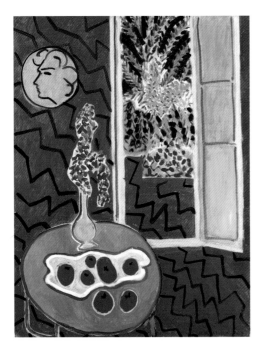

as a colourist. Matisse reported to Brother Rayssiguier on 24 November 1948: 'He's [Picasso] a pure draftsman. Some time ago, I found him doing paintings with squares in different colours. He told me he was trying to find his palette; I had one, there were Matisse blues, even though I use the same blues as everyone else . . . His work with ceramics was a response to this weakness.'[80] Presumably, Picasso felt that he could work Matissean 'magic' with colours in the kiln, where the most extraordinary transformations to the glazes would occur.

On these visits to Matisse, Picasso also witnessed the proliferation of the paper cut-outs. Gilot describes in detail one occasion in December 1947 when they arrived to find Matisse 'armed with a huge pair of scissors, carving boldly into sheets of paper painted in all kinds of bright colours. Delicately holding the piece that suited his purpose in his left hand, he wound it and turned it while his right hand skilfully cut the most unpredictable shapes.' They watched 'spellbound' as Matisse created a symbolic 'portrait' of Françoise and then a gift for the envious Picasso.[81] It is no wonder Picasso was so fascinated by the spectacle of Matisse's dexterity, for as a young child he had been famous in his family for his ability to cut out lifelike silhouettes without the slightest hesitation – a talent he exploited in his Cubist *papiers collés*. As we saw, Picasso was convinced that Matisse had been profoundly influenced by his children's paintings at a crucial moment in his development, and to see Matisse, bedridden and nearly eighty years old, so absorbed with a kindergarten technique was proof that he, Picasso, was right. It was also proof of the general rule in which both put faith that it is vital to rediscover the fresh vision of the child: 'Looking at life with the eyes of a child' is the title of one of

59
Matisse
Red Interior: Still Life on a Blue Table 1947
Oil on canvas 116 × 89 cm
Kunstsammlung Nordrhein-Westfalen, Düsseldorf

Matisse's last statements on art.[82] In Vallauris in the late 1940s and early 1950s Picasso enjoyed himself greatly with techniques that have much to do with children's play: twisting, pushing, prodding and gouging damp clay pots, fresh from the wheel, into the forms of women and animals, and assembling a menagerie of creatures from all kinds of discarded junk stuck together with wet plaster and wire. What these two reborn 'children' produced might look very different, but the impulse was similar and the sense of affinity deeply gratifying to them.

Matisse had used paper cut-outs to aid him in composing the murals for the Barnes Foundation in 1931–3. A full-scale, unfinished trial for the composition is peppered with pin-holes where he attached the papers to the canvas.[83] Photographs confirm that he also used them when revising the composition of The Pink Nude (fig.55). The technique came into its own towards the end of the war when Matisse made the maquettes for the pochoir (stencilled) illustrations for Jazz, published by Tériade in 1947. After 1948, when he completed the last of the Vence interiors, découpage became his primary means of expression. Matisse described his cut-outs as the climax of his art: 'the simplest and most direct way to express myself . . . There is no separation between my old pictures and my cut-outs, except that with greater completeness and abstraction, I have attained a form filtered to its essentials.'[84] The technique satisfied him so much because it fused all his creative activities in a single, decisive action: cutting with scissors reminded him of 'a sculptor's carving into stone,'[85] but it was also 'drawing with scissors',[86] and also painting because the paper was coloured to his specifications with gouache beforehand. A couple of fragments of blue paper laid on a contrasting ground was enough to evoke the silhouette of a woman's torso (fig.66),

but a more complex, and a less sculptural, more decorative effect could be achieved by placing numerous, differently coloured fragments on a variegated background, overlapping them here and there (fig.62). The technique was ultra-simple but extremely flexible, and Matisse's lifelong concerns with the relationship between positive and negative, form and ground, and the creation of sensations of space and light through pure colour, were effortlessly resolved and succinctly restated.

A principal source of the découpage technique was, of course, Cubist papier collé. But Matisse would also have known Picasso's huge decoration created with pasted papers mounted on canvas depicting a bounding Minotaur (fig.60). Dated 1 January 1928, this later served as the maquette for a tapestry woven for Madame Cuttoli in 1935.[87] The large blue cut-out that stands for the creature's torso and sex anticipates the blue cut-outs of Matisse's Venus (fig.66) and Flowing Hair (fig.68) of 1952. Other points of contact are the use of rudimentary 'signs' for the figures and the sense of exhilarating energy. The 'cloisonné' style Picasso used in some of the boldest and most decorative paintings inspired by Marie-Thérèse Walter in the early 1930s, Large Still Life on a Pedestal Table in particular (fig.61), also seems to be an anticipation of the coloured paper maquettes Matisse created for Jazz, for other decorations such as Vegetation (fig.62) and for a succession of stained glass windows, beginning with those for the Vence chapel. Significantly, contemporary critics had likened Picasso's paintings of the 1930s to stained-glass windows because of the heavy black contours trapping the brilliant patches of colour. In short, when Picasso saw Matisse's découpages he must have been aware not just of the continuities with Matisse's earlier decorative paintings, but also of

60
Picasso
Minotaur 1928
Papier collé on canvas
142 × 232 cm
Centre Georges Pompidou,
Paris. Musée National d'Art
Moderne/Centre de Création
Industrielle. Donation de Marie
Cuttoli (Paris) en 1963

their affinities with, and debt to, his own earlier work. The final, triumphant flowering of Matisse's art had brought the two artists into close dialogue once again.

Picasso's immediate reaction to the death of Matisse on 3 November 1954 was terror. He refused to go to the telephone to take calls from Matisse's family who, naturally enough, wanted to hear some expression of sympathy or regret from his lips; he did not go to the funeral. Françoise Gilot believes 'he experienced his friend's death as a kind of betrayal', that 'he felt abandoned'.[88] Characteristically, Picasso became convinced he was ill himself and became temporarily withdrawn. Roland Penrose went to lunch with him in Paris on 21 November and found him still in bed: 'He was sad, looked smaller, more wrinkled and paler than a week ago.

Not forthcoming in conversation.' Persuaded to get up and eat, Picasso at last became communicative: 'Talked of Matisse whose death he certainly feels heavily . . . P. said he had often reproached M. for his religious tendencies but apart from that he said: "Il a fait des Matisses et ça c'est important. [He made Matisses and that's important."]'[89] Later Picasso's hypochondria and superstition took a different turn. Reflecting that, after all, Matisse's doctor must have been exceptionally able since, despite permanent damage to his system and periodic set-backs, Matisse had lived on working productively for almost fourteen years after his first cancer operation, Picasso decided to put himself in the hands of the same doctor and had himself examined regularly by him.[90]

61
Picasso
**Large Still Life on
a Pedestal Table** 1931
Oil on canvas 195 × 130 cm
Musée Picasso, Paris

62
Matisse
Vegetation c.1951
Papier découpé 174.9 × 81 cm
Private collection

Picasso's artistic reaction to Matisse's death went through several stages that are revealing psychologically. Heinz Berggruen has described how when a friend tentatively remarked to Picasso just after Matisse's death that his new drawings looked very like Matisse's, Picasso was not a bit offended, replying: 'You are quite right. But now that Matisse is no longer with us, somebody ought to carry on his work, don't you think?'[91] Impersonation was quickly succeeded by a more complex and ambitious form of posthumous dialogue: the suite of fifteen variations after Delacroix's *Women of Algiers* (fig.46). The first two were painted on 13 December 1954, six weeks after Matisse's death, the last, *Version O*, on 14 February 1955 (fig.63). When he

saw the suite that February, Penrose was instantly reminded of Matisse's odalisques. 'You are right,', said Picasso. 'When Matisse died he left his odalisques to me as a legacy, and this is my idea of the Orient though I have never been there.'[92] Picasso knew full well how immersed Matisse had been in *The Women of Algiers*, and that it was not just his odalisque paintings (notably fig.47) that reflected this, but the entire festooned interior of his apartment-cum-studio at 1, place Charles-Félix in Nice (fig.1); he knew that Matisse had literally lived *in* that painting for many years. In *Version O* Picasso pulled together the various strands developed in the earlier members of the series: the Cubist-derived structural elements particularly

evident in *Version K*, the contrasts of light and dark emphasised in the grisaille canvases *B* and *N*, the colour and pattern of *E*, and so on. He not only pulled them together but he accentuated them, so that while *Version O* is the canvas most indelibly stamped with his own personality and memories of his own art, it is also the canvas that makes more references to Matisse's work than any other in the intensity of its colour, firmness of drawing, proliferation of competing patterns, and inclusion of motifs such as the red-tiled floor (which appears repeatedly in Matisse's Nice interiors) and the doorway/picture-within-the-picture. (See figs.24, 53, 55, 56).[93]

Another audible voice in the Delacroix variations is that of Ingres, especially the Ingres of *Odalisque with Slave* (fig.58), which, like *The Women of Algiers*, was as important to Matisse as to Picasso. It could, indeed, be argued that *Version O* was a reworking of *Serenade* (fig.57) and that Picasso undid the deliberate travesty perpetrated there by, among other things, restoring the orientation of Ingres's composition with the seated figure on the left and the reclining nude on the right. In the series as a whole one senses that Picasso was in a fluctuating, open-ended conversation with Delacroix, Ingres and Matisse, a conversation that may have reproduced some of the things he and Matisse had said to one another about Ingres and Delacroix and painting in general. It may also have involved musing on the fabled opposition between Ingres and Delacroix that had been replicated in the opposition between himself and Matisse, the point being that in both cases there was much more in common between the 'antagonists' than their partisan contemporaries ever really understood.

Conversing – and arguing – with Matisse, as if he were still alive, in the months immediately following his death seems to have been succeeded

by the poignant realisation of actual loss. Gilot attributes to both of them the same statement: 'We must talk to each other as much as we can. When one of us dies, there will be some things the other will never be able to talk of with anyone else.'[94] There would never be any more of those enthralling conversations and, no doubt, too much had never been said. That sense of loss infuses the paintings of Picasso's studio in La Californie, the ornate Art Nouveau villa in Cannes that he bought in 1955 (fig.64). Painted in two bouts in the autumn of 1955 and spring of 1956, as the series developed and grew it became an extended elegy for Matisse who, in dying, not only bequeathed his odalisques to Picasso but also the subject of the artist's studio.

The impact of the Vence interiors (fig.59) can be felt throughout the series, although, in a gesture of

63
Picasso
Women of Algiers, after Delacroix (Canvas O) 1955
Oil on canvas 130 × 195 cm
Private collection

respect, Picasso renounced any attempt to match Matisse's colour and adopted instead an austere palette of bluish or pinkish greys or melancholy browns and blacks, enlivened only by small touches of bright colour. The sense of absence is conveyed by the impression given of work in progress abandoned suddenly, of deathly quietude in the deserted studio. Motifs indelibly associated with Matisse are included: windows that function like pictures-within-the-picture and provide glimpses of palm trees and foliage; paintings and sculptures dotted about among the stacked canvases turned face to the wall. In some members of the series (such as fig.64), the Art Nouveau windows imitate the foliage shapes in paintings such as *Music* (fig.56) and in Matisse's late cut-outs (fig.62), and a Moroccan brass charcoal burner, identical to the one in his odalisque scenes of the 1920s, makes an unexpected

appearance. Picasso also echoed Matisse's two main methods of drawing spontaneously in the Vence interiors, now drawing swiftly with liquid paint, now scoring the wet paint with the wooden end of his brush. Yet, for all their Matissean aspects these elegiac canvases do not pastiche the Vence interiors, and in their theatrical representation of the studio and its points of exit and entrance they are typical of Picasso's work, testifying to his constant indifference to the oriental conventions of design that influenced Matisse so deeply.

Another stage in the posthumous dialogue was reached in the early 1960s when Picasso created his final series of sheet-metal sculptures with the help of Lionel Prejger. In these the sense of regret and mourning is totally absent; the mood is exuberant, witty, playful and indeed cheerful. In every case Picasso made the life-size maquette in cut and folded paper or card; Prejger's job was to oversee its translation into sheet metal in his factory and then either leave it in its naked state or coat it in white paint. Picasso would then decorate the piece or not, as he saw fit. Prejger has given vivid accounts of Picasso's commitment to this enterprise, his unflagging energy and childish impatience for instant results, his readiness to experiment and his perfectionism, above all his intense enjoyment of the whole business.[95] Picasso was usually happiest when making sculpture and these works took him right back to his dazzling feats of paper-cutting as a child. It is impossible not to make the connection with his silent admiration for Matisse at work on his *découpages*, experiencing in old age an extraordinary upsurge of exultant creativity. In 1960, when Picasso made his first sheet-metal sculptures with Prejger, he was on the point of turning eighty and, like Matisse, he felt rejuvenated.

64
Picasso
The Studio 1956
Oil on canvas 89 × 116 cm
Helly Nahmad Gallery, London

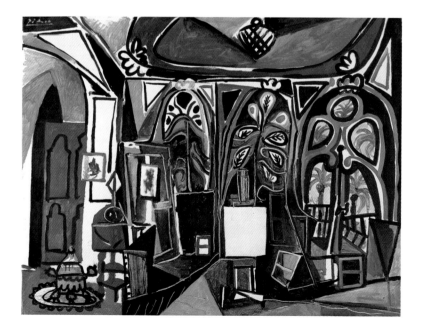

The similarities between these sheet-metal sculptures and Matisse's cut-outs are remarkable, although as usual one is simultaneously aware of difference. Compare, for example, the use of positive and negative in Picasso's *Woman* (fig.65) with that in Matisse's *Venus* (fig.66), the difference being that the equivalent to solid form in Picasso's sculpture is the negative white ground in Matisse's cut-out. In both the sharply cut silhouette is 'carved' and active, drawing and sculpting fusing in one movement; 'empty' space is as important in both for evoking the sense of solid form – a paradox that delighted both artists. Or compare the role of cutting, bending out and lifting up the form of, say, the breasts or the hair in Picasso's *Woman with a Tray and Bowl* (fig.67) with the way in which Matisse slices into the back of the ecstatic maenad in *Flowing Hair* (fig.68) to suggest the muscular twisting of her torso as she runs. For both artists abbreviated signs for parts of the body and a deft movement of the scissors prove as telling as the most painstaking, realistic description: for instance, the snicks that suggest the mouth and the zig-zag fold of the arm in *Head of a Woman*, and the vase

65
Picasso
Woman 1961
Sheet metal 30 × 20 × 11.5 cm
Private collection

66
Matisse
Venus 1952
Gouache on paper, cut and
pasted, on canvas
101.2 × 76.5 cm
National Gallery of Art,
Washington DC. Ailsa Mellon
Bruce Fund 1973

67
Picasso
Woman with a Tray and a Bowl 1961
Painted sheet metal
114.6 × 62 × 35.5 cm
Private collection

68
Matisse
Flowing Hair 1952
Gouache on paper, cut and pasted, on paper 108 × 80 cm
Private collection

shape and swellings that evoke the neck and the breasts in *Venus*.

Yet although Picasso's sheet-metal sculptures have a strongly pictorial feel, and are designed, like free-standing high reliefs, to be seen from only a limited number of angles, they change radically, as free-standing sculpture does, when the spectator shifts position. Equally, the figure depicted is the focus of attention: the surrounding space and the space captured in the openings have a subordinate role and serve to define the figure's form and

assert its physical reality. In Matisse's cut-outs, by contrast, the space is just as important as the figure and the relationship of the figure to the rectangular surface is crucial: these are pictorial compositions and the format is of prime importance to the effect. Ultimately, then, the fundamental differences in vision that had always separated Matisse and Picasso, and which emerge when one compares the two paintings they exchanged in 1907 (figs.17, 18), survived in this culminating act of their creative dialogue.

Notes

1 Unpublished typescript of Matisse's conversations with Pierre Courthion, 1941, Archives Matisse, Paris, [n.p.].

2 Henri Matisse, M.-A. Couturier, and L.-B. Rayssiguier, *The Vence Chapel: The Archive of a Creation*, ed. Marcel Billot, trans. Michael Taylor, Milan 1999, p.86.

3 Letter to Picasso from Matisse, Archives Picasso, Paris. Matisse did not see the decorations Picasso had painted in 1946 in the museum in Antibes until 1948. For Matisse's drawings of them, see Yve-Alain Bois, *Matisse and Picasso*, Paris 1998, pp.192–204.

4 'Picasso et ses environs', in André Verdet, *Enteriens: Notes et écrits sur la peinture: Braque, Léger, Matisse, Picasso*, Paris 1978, p.139.

5 Fernande Olivier, *Picasso and his Friends*, trans. Jane Miller, London 1964, pp.16, 26–7.

6 Ibid., p.88.

7 Ibid., p.84.

8 Jack Flam (ed.), *Matisse on Art*, London 1973 (revised ed. Berkeley and Los Angeles 1995). See also Dominique Fourcade, *Henri Matisse: Ecrits et propos sur l'art*, Paris 1972.

9 Dore Ashton, *Picasso on Art: A Selection of Views*, London 1972. See also Marie-Laure Bernadac and Androula Michael, *Picasso: Propos sur l'art*, Paris 1998.

10 For these scandals and their devastating effect, see Hilary Spurling, *The Unknown Matisse: A Life of Henri Matisse*, I, 1869–1908, London 1998, pp.230–70.

11 Berthe Weill showed their work in several different exhibitions between 1902 and 1905. Charles Morice wrote favourable reviews of Picasso's show at Weill's gallery in autumn 1902 and Matisse's show at Vollard's gallery in 1904. He also wrote the preface for Picasso's exhibition of Harlequin and Saltimbanque paintings at the Galerie Serrurier in February–March 1905.

12 Leo Stein, *Appreciation: Painting, Poetry and Prose*, New York 1947, p.158. For further discussion of the date of the artists' first meeting,

see 'Chronology', *Matisse Picasso*, exh. cat., Tate Modern, London 2002, p.362.

13 The term *'fauve'* (wild beast) was first used by the critic Louis Vauxcelles to describe the impact of the paintings in his review in *Gil Blas*, 17 October 1905.

14 Olivier 1964, p.27.

15 Gertrude Stein, *The Autobiography of Alice B. Toklas* (1933), Harmondsworth 1966, p.9. The two other 'first class geniuses' named are Alfred Whitehead and Stein herself.

16 Ibid., p.60.

17 Ardengo Soffici, *Ricordi de vita artistica e letteraria*, Florence 1942, pp.365–6.

18 Max Jacob, 'The Early Days of Pablo Picasso', *Vanity Fair*, May 1923; cited in Hélène Seckel, *Max Jacob et Picasso*, exh. cat., Musée Picasso, Paris 1994, p.193.

19 Matisse, in conversation with Pierre Courthion in 1941 (see n.1, above).

20 André Malraux, *La Tête d'obsidienne*, Paris 1974, p.18. Malraux says his conversation with Picasso about his discovery of *art nègre* took place in 1937.

21 Ibid., p.17.

22 André Salmon, *La Jeune Peinture française*, Paris 1912, p.44.

23 Louis Vauxcelles in *Gil Blas*, 20 March 1907.

24 Walter Pach, quoted in Spurling 1998, p.376.

25 Picasso's first recorded reference to this episode is in a letter to Kahnweiler of 12 June 1912, quoted in Isabelle Monod-Fontaine, *Donation Louise et Michel Leiris: Collection Kahnweiler-Leiris*, exh. cat., Musée National d'Art Moderne, Centre Georges Pompidou, Paris 1984, p.168.

26 See John Elderfield, 'Moving Aphrodite: On the Genesis of *Bathers with a Turtle* by Henri Matisse', *Henri Matisse: Bathers with a Turtle*, The Saint Louis Art Museum Fall 1998 Bulletin, pp.20–49.

27 Stein 1966, pp.72–3.

28 Ibid., p.72.

29 John Richardson, in *The Age*, 22 December 1962; cited in Ashton 1972, p.164.

30 Pierre Daix, *Picasso: Life and Art*, trans. Olivia Emmet, London 1993, pp.63–4.

31 Henri Matisse, 'Notes of a Painter', *La Grande Revue*, 25 December 1908, in Flam 1973, pp.35–6.

32 Quoted in Isabelle Monod-Fontaine and Claude Laugier, 'Eléments de chronologie', *Henri Matisse 1904–1917*, exh. cat., Musée National d'Art Moderne, Centre Georges Pompidou, Paris 1993, p.101.

33 Françoise Gilot, *Matisse and Picasso: A Friendship in Art*, London 1990, p.14.

34 Ibid., p.316.

35 Quoted by Jean Sutherland Boggs in *Picasso and Things*, exh. cat., The Cleveland Museum of Art 1992, p.268.

36 Matisse's comments are recorded in François Campaux's documentary film, *Matisse* (1946).

37 'Notes of a Painter' 1908, in Flam 1973, p.38.

38 See Jack Flam, *Matisse: The Man and his Art, 1869–1918*, London 1986, p.314.

39 E. Tériade, 'Matisse Speaks', 1951, in Flam 1973, p.132.

40 See the letters from Eva Gouel and Picasso to Gertrude Stein excerpted in Judith Cousins, 'Chronology', in William Rubin (ed.), *Picasso and Braque: Pioneering Cubism*, exh. cat., The Museum of Modern Art, New York 1989, pp.421–2. Matisse also wrote to Gertrude Stein to describe the horserides.

41 'Matisse: A propos du dessin et des odalisques', in Verdet 1978, p.127.

42 See Flam 1986, p.371.

43 The photograph is from a series of Matisse at work taken by Alvin Langdon Coburn in the Issy studio. It is reproduced in John Elderfield, *Henri Matisse: A Retrospective*, exh. cat., The Museum of Modern Art, New York 1992, p.236.

44 Cited in *Henri-Matisse 1904–1917*, 1993, p.494. Apollinaire's very favourable comments are also quoted.

45 See Dominique Fourcade, 'Greta Prozor', *Cahiers du MNAM*, no.11, Centre Georges Pompidou, Paris 1983, pp.101–7.

46 Léonce Rosenberg, letter to Picasso, 25 November 1915, Archives Picasso, Paris; cited in Bois 1998, p.11.

47 Cited in Daix 1993, p.147.

48 Flam 1986, pp.423–8.

49 Tériade 1951, p.132.

50 Ibid., p.131.

51 *La Révolution Surréaliste*, no.4, 15 July 1925, pp.26–30.

52 Letter from Matisse to Marguerite Duthuit, 13 June 1926, Archives Matisse, Paris.

53 The second instalment of Breton's 'Le Surréalisme et la peinture', *La Révolution Surréaliste*, no.6, 1 March 1926, contains a further tribute to the 'genius' of Picasso and a denunciation of the recent work of Matisse and Derain, described as 'these old discouraging and discouraged lions' (p.31).

54 André Breton, letter to Matisse, 5 February 1948, Archives Matisse, Paris; extracted in *André Breton: La Beauté convulsive*, exh. cat., Musée National d'Art Moderne, Centre Georges Pompidou, Paris 1991, p.87. It was almost certainly this version, not its sketchier pair (now in the Metropolitan Museum of Art, New York).

55 'Notes of a Painter' 1908, p.36.

56 See Matisse, 'Black Is a Colour' (1946), in Flam 1973, pp.106–7.

57 'Picasso Speaks', *The Arts*, May 1923, in Ashton 1972, p.4. His interlocutor was Marius de Zayas.

58 Claude Roger-Marx, 'Oeuvres récentes d'Henri Matisse', *Le Jour*, 9 May 1936.

59 Louis Gillet, 'Trente ans de peinture au Petit Palais', *Revue des Deux Mondes*, 1 August 1937, pp.577–8.

60 See Bois 1998, p.58.

61 Claudine Grammont (ed.), *Correspondance entre Charles Camoin et Henri Matisse*, Lausanne 1997, p.115.

62 Helen Appleton Read, 'Matisse, Accepted at Last', *Brooklyn Eagle Magazine*, 26–31 July 1931.

63 Their meetings are fully documented in the 'Chronology', *Matisse Picasso* exh. cat. 2002; extracts of representative press criticism are also cited there.

64 Louis Mouilleseaux, 'Expositions: Manet – Picasso', *Le Cahier*, June–July 1932, p.46.

65 For a much fuller discussion of these paintings, see Robert Rosenblum, 'Picasso's Blond Muse: The Reign of Marie-Thérèse Walter', in William Rubin (ed.), *Picasso and Portraiture: Representation and Transformation*, London 1996, pp.342–62.

66 Daix 1993, p.219.

67 The states and several of the preparatory drawings are reproduced in Lydia Delectorskaya, *With Apparent Ease . . . Henri Matisse: Paintings from 1935–1939*, trans. Olga Tourkoff, Paris 1988, pp.58–9, 62–6.

68 See, for example, John Elderfield's discussion in *Matisse Picasso*, exh. cat. 2002, pp.233–9.

69 Roger-Marx 1936.

70 Matisse, *Bouquet of Flowers in a Chocolate Pot*, c.1902, Musée Picasso, Paris.

71 For the photographic record and Matisse's words, see Delectorskaya 1988, pp.305–15.

72 Eric Newton, 'Storm over Picasso', *Manchester Guardian*, 22 December 1945, p.4.

72 Ibid.

74 Brassaï, *Picasso and Co.*, trans. Francis Price, London 1966, p.218.

75 Jane Simone Bussy, 'A Great Man', *The Burlington Magazine*, vol.128, February 1986, p.81. The memoir is believed to have been read out at the Bloomsbury 'Memoir Club' in the autumn of 1947.

76 See Françoise Gilot and Carlton Lake, *Life with Picasso*, London 1965, and Françoise Gilot, *Matisse and Picasso: A Friendship in Art*, London 1990.

77 See Bois 1998, pp.192–204, for illustrations and an analysis.

78 See Gilot 1990, pp.195–6.

79 The whole series of drawings was first published as 'Suite de 180 dessins de Picasso', in *Verve*, nos.29–30, September 1954, just before Matisse's death.

80 Matisse, Couturier and Rayssiguier 1999, p.116.

81 Ibid., pp.71–6.

82 'Looking at Life with the Eyes of a Child' (1953) was first published in *Art News and Review*, 6 February 1954; see Flam 1973, pp.148–9.

83 See Jack Flam, *Matisse: The Dance*, exh. cat., National Gallery of Art, Washington D.C. 1993.

84 'Testimonial' (1951), first published by Maria Luz as 'Témoinages: Henri Matisse', *XXè Siècle*, January 1952; see Flam 1973, p.137.

85 Henri Matisse, *Jazz*, Paris, 1947; see Flam 1973, p.112.

86 Ibid.

87 *Minotaur* was reproduced in 'Hommage à Picasso', *Documents*, 1930, no.3, p.145. Since Matisse also designed a tapestry for Madame Cuttoli in 1935 he is likely to have known it in the original.

88 Gilot 1990, p.317.

89 Manuscript notes in the Roland Penrose Archive, Scottish National Gallery of Modern Art, Edinburgh, GMA 0580-04.

90 Brassaï, reporting information from Kahnweiler during a conversation on 21 October 1962, in Brassaï 1966, p.270.

91 Heinz Berggruen, *J'étais mon meilleur client: Souvenirs d'un marchand d'art*, trans. Laurent Muhleisen, Paris 1997, p.184.

92 Roland Penrose, *Picasso: His Life and Work*, Harmondsworth 1971, p.406.

93 The series as a whole is discussed in Leo Steinberg, 'The Algerian Women and Picasso at Large', in *Other Criteria: Confrontations with Twentieth-Century Art*, Oxford 1972, pp.125–234, and in Susan Grace Galassi, *Picasso's Variations on the Masters: Confrontations with the Past*, New York 1996, pp.127–47.

94 Gilot 1965, p.255. Here the comment is attributed to Matisse. In Gilot 1990, p.316, she quotes Picasso: 'There are a number of things I shall no longer be able to talk about with anyone after Matisse's death.'

95 Lionel Prejger, 'Picasso découpe le fer', *L'Oeil*, no.82, October 1961, pp.28–32; see also the interview with Prejger in Elizabeth Cowling and John Golding (eds.), *Picasso: Sculptor/Painter*, exh. cat., Tate Gallery, London 1994, pp.241–53.

Index